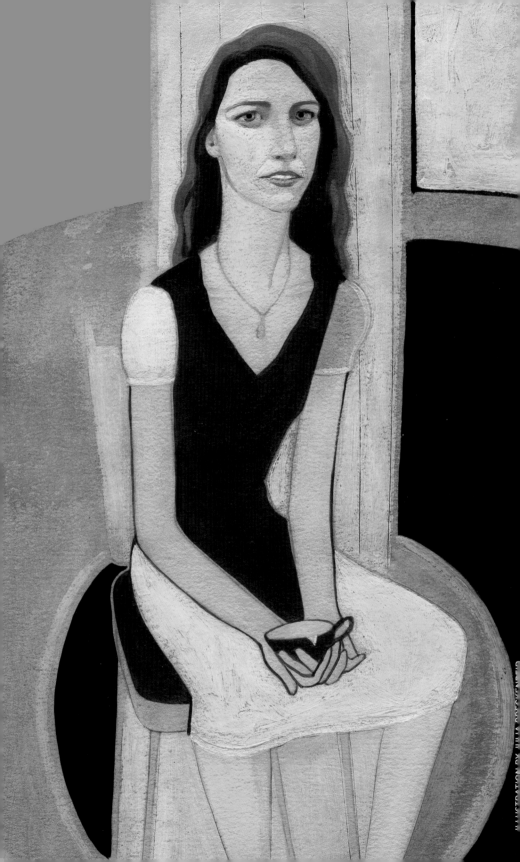

No3

THREE BY THREE ILLUSTRATION ANNUAL

Sponsored by 3x3 Magazine

PUBLISHED IN 2007 BY

3X3 MAGAZINE : 244 FIFTH AVENUE : SUITE F269 : NEW YORK NEW YORK 10001

PROFESSIONAL SHOW JUDGES

Bob Barrie
FALLON USA

Stephen Rutterford
BBH/UK

Shawn Smith
FALLON USA

William Webb
BLOOMSBURY

Stefan Keifer
DER SPIEGEL

Joe Morse
Sharon Tancredi
Peter de Sève
ILLUSTRATORS

CHILDREN'S BOOK SHOW JUDGES

Anne Schwartz
RANDOM HOUSE

Anne Moore
CANDLEWICK PRESS

Cecilia Young
PUTNAM

Serge Bloch
Etienne Delessert
Pascal LeMaître
Sergio Ruzzier
ILLUSTRATORS

STUDENT SHOW JUDGES

Kurt Vargo
Paul Dallas
Jean-Manuel Duviver
Chrystal Falcioni
Tom Garrett
Viktor Koen
Barbara Nessim
ILLUSTRATORS

Vicki Morgan
MORGAN-GAYNIN

No3

THREE BY THREE ILLUSTRATION ANNUAL

Sponsored by 3x3 Magazine

HONORING
Ann Field
ILLUSTRATOR: EDUCATOR OF THE YEAR

PUBLISHER + DESIGN DIRECTOR
Charles Hively

ART DIRECTOR + DESIGNER
Sarah Munt

COPY EDITOR
Kate Lane

INTERNS
Daniel F. Birch
Justin Gabbard

COVER ILLUSTRATION BY
Eddie Guy

PRINTED IN CANADA BY
Westcan Printing Group

ONCE AGAIN WE ARE PROUD TO PRESENT THE BEST WORK DONE BY ILLUSTRATORS TODAY. WHAT YOU ARE ABOUT TO SEE ARE THE WINNING IMAGES FROM 2006 AS JUDGED BY OUR DISTINGUISHED PANEL OF JUDGES FOR THREE COMPETITIONS. ONE STUDENT. ONE PROFESSIONAL. AND THE OTHER, A BRAND NEW CATEGORY, CHILDREN'S BOOK ILLUSTRATION. THE RESULT: AN ADDITION TO A TIME CAPSULE OF THE BEST WORK IN ILLUSTRATION FROM THE EARLY TWENTY-FIRST CENTURY, WORK THAT I BELIEVE YOU'LL AGREE WILL UNDOUBTEDLY STAND THE TEST OF TIME. NOT EVERY ARTIST IS REPRESENTED IN THIS VOLUME, WE CAN ONLY JUDGE WHAT IS SUBMITTED, SO WE CAN'T CLAIM TO HAVE ONLY THE BEST. BUT AFTER VIEWING OVER TWENTY-TWO HUNDRED ENTRIES OUR JUDGES HAVE GATHERED IN THIS VOLUME THE BEST PROFESSIONAL AND STUDENT WORK FROM AROUND THE GLOBE PRODUCED LAST YEAR. SO FIND YOURSELF A GOOD COMFORTABLE CHAIR, HAVE A SEAT, TURN THE PAGE AND BE READY TO BE ENTERTAINED, ENLIGHTENED AND INSPIRED. ENJOY! — THE PUBLISHER

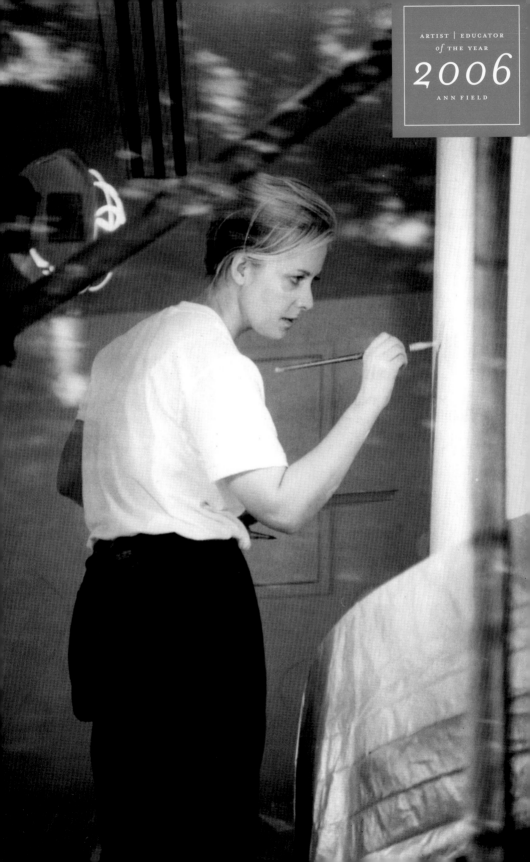

THE NAME ANN FIELD *has become synonymous with award-winning, innovative images that cross between the disciplines of design, photography and illustration. Her work has been an integral part of interior and exhibit design, and has been used in diverse branding campaigns for leading clients including Levi's, Lexus, Barney's, Target, Mattel, Starbucks and Nike. Her work is also part of the permanent collection of Cooper-Hewitt, National Design Museum in New York.*

She has always wanted to be an illustrator. After graduating from Brighton College of Art in her native England, her career path included stops at London's EVENING STANDARD, MADEMOISELLE *and Italian* VOGUE *before she began working with renowned New York fashion illustrator Antonio Lopez. Moving to California in the 1980s, she started her own company and began teaching at Otis College of Art and Design in Los Angeles.*

The co-author of three books published by Chronicle, Ann lectures frequently and has served as president of ICON, The Illustration Conference and was recently named chair of the illustration department at Art Center College of Design in Pasadena, California. Ann continues working on illustration assignments and is currently involved in character designs for an upcoming Uma Thurman project. We here at 3x3 salute Ann on her many achievements and welcome her as our Educator of the Year, 2006. —THE PUBLISHER

Q Where did you grow up?

A In Brighton, England, in Sussex County, right on the English Channel on the south coast of England. It's a very historic and creative place, known for its famous theater and as a haven for artists and writers. It is also a major vacation destination spot—kings and queens have been known to holiday there.

Q Tell us about your early schooling in the UK. Did you always want to be an illustrator?

A Yes! There was never any doubt in my mind. As early as I can remember, I wanted to draw and knew that that was what I wanted to do with my life. My earliest memory is of drawing a picture on my first day of kindergarten…and of a crowd gathering around me, admiring what I had done and asking me questions. I knew, from a child's point-of-view, that I had been given a talent. And this has guided all my decisions since.

I actually started studying art from a very early age. I was singled out in school and was sent to extra classes on Saturdays, working with students much older than myself. Being able to observe all their skills and talents was really a fantastic experience—I knew I wanted to be just like them.

Once I left school, I studied at Brighton College of Art, which is now part of the Sussex University. It was—and still is—one of the best of art schools in the United Kingdom. It has an outstanding reputation that it truly deserves. During my time at Brighton, I also took some tutorial classes at the Royal College of Art in London. After immigrating to the United States, I studied briefly at UCLA.

Q What were some of your early influences?

A England has a great tradition of book illustration and so I started out loving the work of Arthur Rackham and Aubrey Beardsley, E.H. Shepard's illustrations for Winnie-the-Pooh and all of the classics. I still love children's book illustration and vividly remember being enchanted by Beatrix Potter. Animals and British whimsy were

also early influences.

By 16, Andy Warhol was a huge influence. Pop Art and the audacity of that art movement inspired me to break new boundaries in my own work. During my student years, the design and architecture of the Modernist and Art Deco movements fascinated me. I was also intrigued by production design—I remember looking at film storyboards and theme boards, particularly those of Alfred Hitchcock.

Additionally, I was a big fan of New York fashion illustrator Antonio Lopez, who is now deceased. He forged a great drawing style based on observation and attitude. I learned a lot from studying Antonio, and then also from later having the privilege to know and work with him. And, of course, Milton Glaser inspired me when I was young and continues to inspire to this day.

Q What illustrators do you currently admire?

A So many! I think that is one reason why I was voted president of ICON, The Illustration Conference—I seemed to know of everyone in every area within illustration and was a fan of them all! It was a happy convergence of my obsession with illustration and my awe of the people doing illustration today.

James Jean is doing interesting things. He can draw and is using the comic book world as inspiration, but his pieces look like something else altogether. I like his intelligence and his mix of hand and digital. Sean Cheetham, an Art Center alum, is an iIllustrative portrait painter—his work is remarkable. He was part of the National Portrait Gallery's BP Portrait Award Exhibition in 2005 and his work won placement on the cover of the exhibition catalogue.

And Christian Scheurer, author of *Entropia*, does fantastic entertainment work that is really pushing boundaries.

Q After graduation, how did you get your first big break?

A I actually worked first as a journalist on London's *Evening Standard*. I wanted to progress from writing to working on illustration full time, so I was working on concurrent freelance illustration projects.

Q What prompted you to move to the US?

A Many things prompted my move to the States. Like any immigrant, I wanted a chance at a better life. From a creative standpoint, I've always felt that greater opportunities presented themselves here. I also enjoyed the energy and freedom of this country. I still love all those things—so much so that I became a citizen in 2004.

Q How did you get the job working with Antonio? What did you learn from him?

A At the time, I was teaching in the fashion department at Otis College. Antonio was doing a trip to the Dominican Republic and wanted teachers to work with him. What I learned from him: soul, flair, the absolute connection from line to life.

Q Why the move to the West Coast?

A Friends had moved to California, which was then—and still is, at least in my quite partial mind—the place to be. Plus, I am still taken with the idea of sun nearly every day. Still an English girl at heart, in that way, I suppose.

Q Though it all relates to fashion in some way or another, your work is quite diverse—why this choice?

A In college, my diversity was viewed as a problem. It was hard for people to figure out quite what to do with me, and where I

should be focusing my attention. But, in retrospect, I see that it has enabled my longevity. Now I use it as the mainstay of my practical understanding for the profession. Everything I have done actually seems to have anticipated today's illustration market—odd but true.

Q Your work incorporates design and photography as well as illustration. Do you find it easy to move between art and photography?

A For me, the two have become intimately connected. It started when I was looking at a lot of photography and getting many ideas from the content. I wasn't working from photographs per se, but I was a fan of the form and I felt that its visuals were key. And so this evolved into me wanting to take the photographs myself. I was hoping to create and have control over what that image was going to look like. I don't feel I've come close to mastering "photography," but I feel that I can gain mastery over the individual photographs I need for my work.

Q You've worked in editorial, books, institutional and advertising. Tell us a bit about working in advertising. Some of the pleasures? Some of the frustrations?

A Advertising is very seductive. If your work is part of a large campaign, it is everywhere and the whole world sees it. Seeing my billboard for Levi's jeans for women in Times Square was really quite something. It's also exciting in that you do have to work as a team, which is contrary to the somewhat solitary life of the illustrator. I enjoy it—I see working within specific adver-

tising content parameters or creating an idea as a challenge. I also think it's important as to influencing the way a piece should actually look. And, fortunately for me, my style is strong enough that my look shines through, no matter where the piece ends up. And not to sound mercenary, but the money is also quite good.

Q In looking at your work, we notice there seems to be an absence of male imagery. Is this intentional?

A That's odd—I had never actually thought of that! And no, I'd have to say it's not on purpose. But I guess where you'll see the presence of male imagery the most would be in my life drawing work. As for commissioned work, I guess the client sees me in a particular way, as a particular type of illustrator, and uses me for their particular purpose. The direction has pretty much been created by client perception!

Q Let's talk about your experiences as a teacher. What do you feel is an instructor's role?

A I think the role of a teacher is to help students define who they are and to force them to commit to their ideas and opinions. It also amazes me that the hands-on, real world experience I've had as a working illustrator really does translate into being able to offer much to my students—happily so.

Q Do you feel there is anything missing in today's education of an illustrator?

A One thing that I do feel is missing are adaptable skills. I also strongly believe that a sense of the modern marketplace is essential and sometimes missing. One of the reasons I'm thrilled to be at Art Center and chair of the illustration department is because there's been such openness towards working to integrate those two things into our core curriculum.

Q What is your advice to someone entering the field today?

A Be aware of the changes that are redefining the profession—there are areas that can be potential career fields and need to be seen as such. Be able to move from working on an illustration to painting to producing a motion piece to entertainment projects. I'd also tell them to gain an understanding of the commercial side of art, the business side—learn to be an entrepreneur.
The final piece of advice is to have an unbelievable skill set. Keep working to improve your skills—not just your technique, but also your ideas. This happens when you strive for personal growth as a creative person, and when you do it in ways that are honest, unique and relevant.

Q What has it been like transitioning from full time illustration to being chair at Art Center?

A It's been a wonderful experience—like being a student again. I have devoted my entire life to my work, to art and to illustration. I've gained so much experience and success and I very much wanted to share it with others. Teaching wasn't something new to me, though. I've always taught, in addition to working as an illustrator. But being the chair of the department is new, and is incredibly rewarding and exciting.

Q Any final words to graduates?

A "Contemporary" and "relevant" are the buzzwords at Art Center that I fully embrace—as in "be contemporary and stay relevant." But, in my mind, this must always be underscored by the most vital component for any illustrator: great professional skills.

Q What do you think about the current state of illustration?

A Actually, it's better than ever—yet, at the same time…harder than ever. You have to know where your work belongs in the marketplace and understand which of your skills and specializations are the most appropriate on any given occasion. Ideas are the new frontier. Generating your own, collaborating with others, working as team on a project—it's all about the idea.

Q You are married to designer Clive Piercy. Are you able to collaborate on projects?

A Yes. In fact, collaborating with Clive has been the greatest working relationship of my life. To work with a brilliant and objective art director can help make an illustrator. It can also take you to new creative heights.

Q Finally, what kinds of projects are you working on now?

A How nice of you to ask! The Chairs are expected to stay current and work and lecture continuously. So currently I am working on a campaign for Target, character designs, a book proposal for a project of my own and an ad campaign for Quicksilver/Roxy. which is terrific and very enjoyable. I don't see myself ever stopping working. It's truly my greatest happiness.

THREE BY THREE PROFESSIONAL SHOW

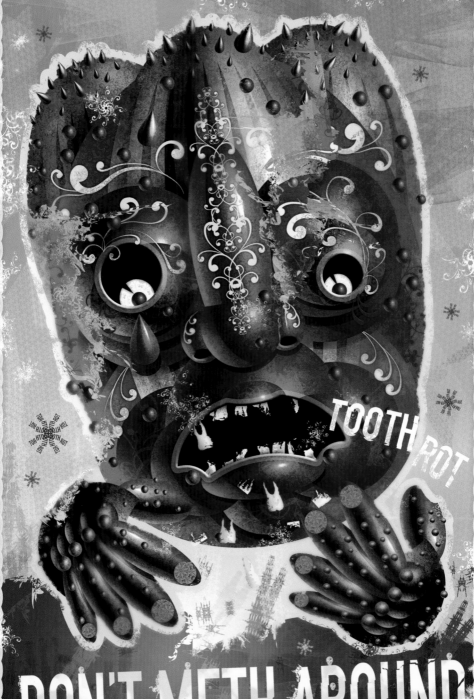

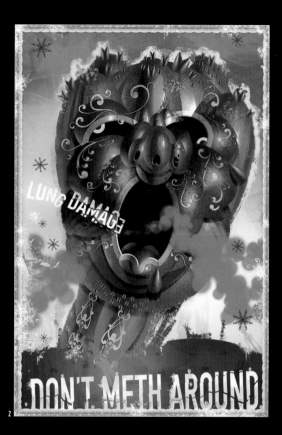

1-3 ART DIRECTOR:
Coby Neil
ILLUSTRATOR:
Kristian Olson
DESIGN AGENCY:
Noble & Associates
CLIENT:
*Anti-Methamphetamine
Campaign*

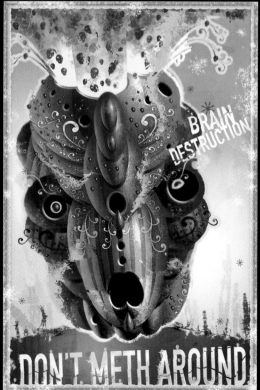

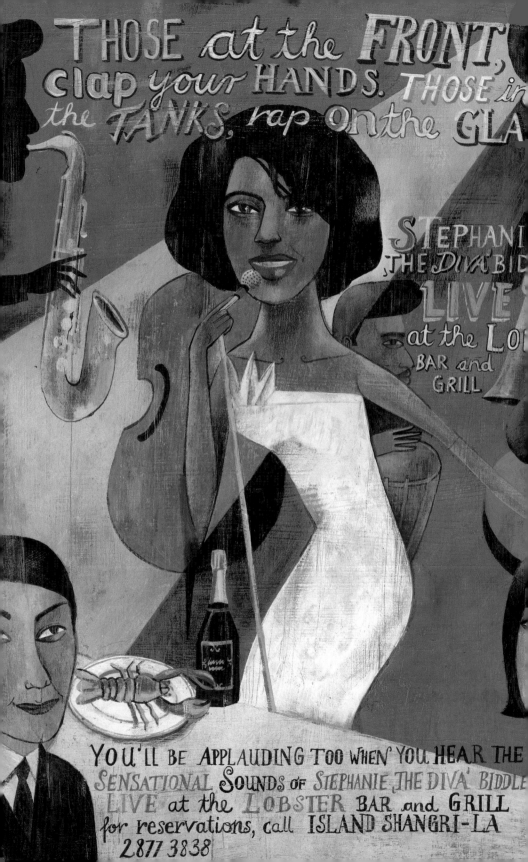

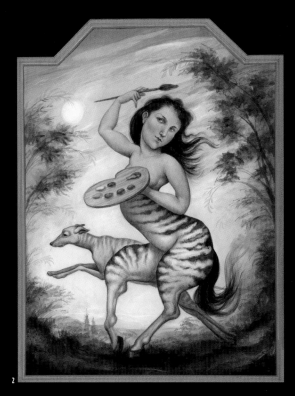

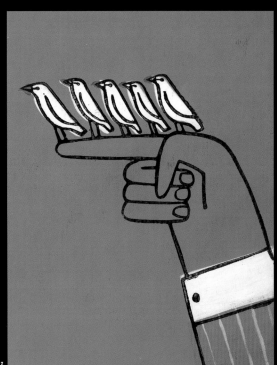

1 ART DIRECTOR:
Malcolm Costain
ILLUSTRATOR:
Olaf Hajek
DESIGN AGENCY:
TBWA, Hong Kong
CLIENT:
*Lobster Bar, Island
Shangri-La*

2 ART DIRECTOR:
Anthony Padilla
DESIGNER:
Anthony Padilla
ILLUSTRATOR:
Anita Kunz
CLIENT:
*Laguna College of Art
& Design*

3 ART DIRECTOR:
Bob Barrie
ILLUSTRATOR:
Carey Sookocheff
DESIGN AGENCY:
Fallon Minneapolis
CLIENT:
United Airlines

2

3

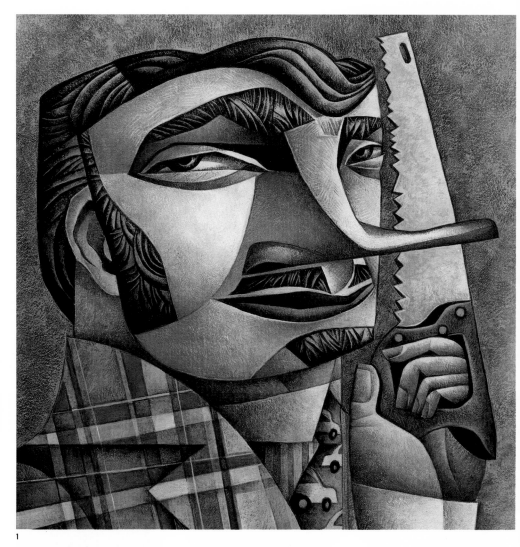

1

2

3

4

1-4 ART DIRECTOR:
Niki Taylor
DESIGNER:
Niki Taylor
ILLUSTRATOR:
Sara Tyson
DESIGN AGENCY:
Holmes and Lee
CLIENT:
*NewRoads Automotive
Group*

5 ART DIRECTOR:
Carrol Kemp
ILLUSTRATOR:
Douglas Fraser
CLIENT:
Red Car Winery

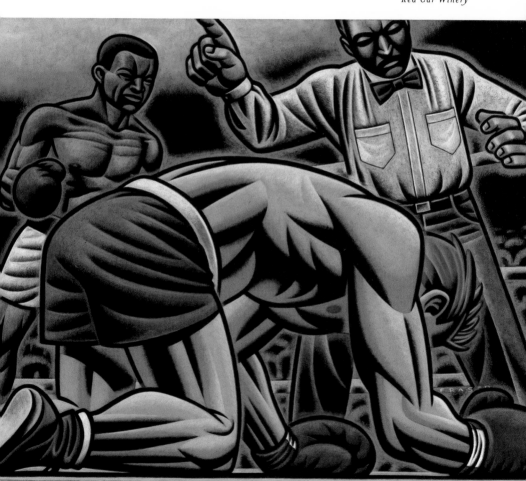

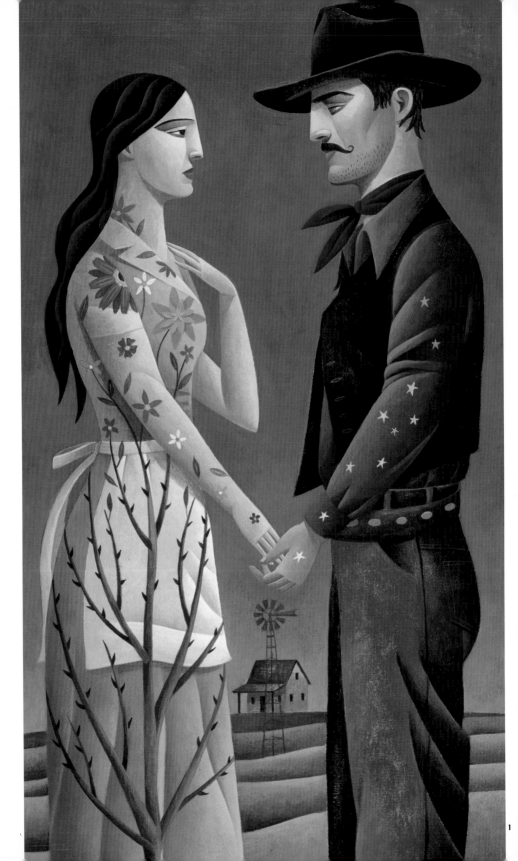

1

1 ART DIRECTOR:
Maggie Boland
DESIGNER:
Scott Mires
ILLUSTRATOR:
Jody Hewgill
DESIGN AGENCY:
Mires Ball
CLIENT:
Arena Stage

2 ART DIRECTOR:
Jeff Kowal
DESIGNER:
Jeff Kowal
ILLUSTRATOR:
Michael Gibbs
CLIENT:
Pittsburgh Opera

3 ART DIRECTOR:
Mike Diehl
DESIGNER:
Brian Cairns
ILLUSTRATOR:
Brian Cairns
DESIGN FIRM:
Mike Diehl Design
CLIENT:
Warner Records

1

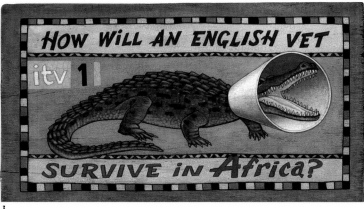

1 ART DIRECTORS:
Greg Newbold,
Eric Gillett
DESIGNER:
Eric Gillett
ILLUSTRATOR:
Greg Newbold
DESIGN AGENCY:
Gillett & Co.
CLIENT:
Downtown Alliance/
Downtown Farmer's
Market

2 ART DIRECTOR:
Bob Barrie
ILLUSTRATOR:
Beppe Giacobbe
DESIGN AGENCY:
Fallon Minneapolis
CLIENT:
United Airlines

3 ART DIRECTOR:
Tiger Savage
ILLUSTRATOR:
Marc Burckhardt
DESIGN AGENCY:
M&C Saatchi
CLIENT:
ITV

2

3

1

Beppe Giacobbe
DESIGN AGENCY:
Fallon Minneapolis
CLIENT:
United Airlines

2

3

4

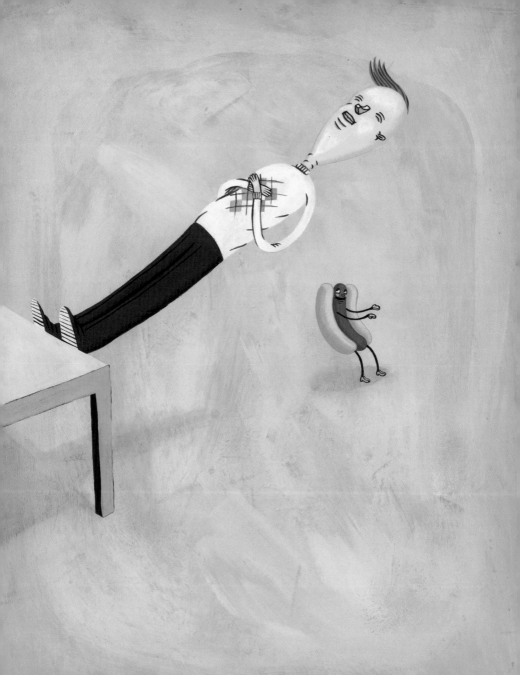

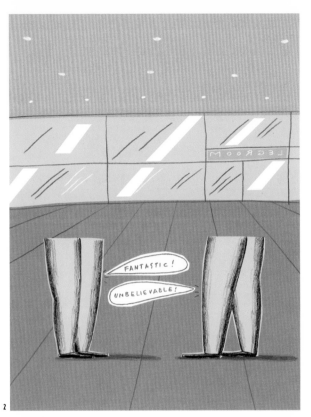

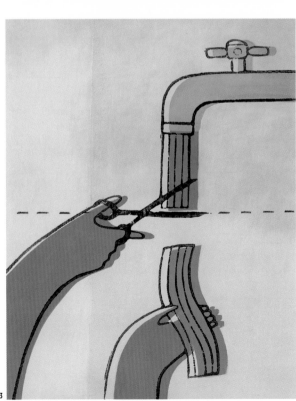

1 ART DIRECTOR:
Travis Lampe
ILLUSTRATOR:
Travis Lampe
DESIGN AGENCY:
Downtown Partners Chicago
CLIENT:
Vienna Beef

2 ART DIRECTOR:
Bob Barrie
ILLUSTRATOR:
Guido Scarabottolo
DESIGN AGENCY:
Fallon Minneapolis
CLIENT:
United Airlines

3 ART DIRECTOR:
Carey George
ILLUSTRATOR:
Carey Sookocheff
DESIGN AGENCY:
Up Inc.
CLIENT:
Fairmont Hotels & Restorts

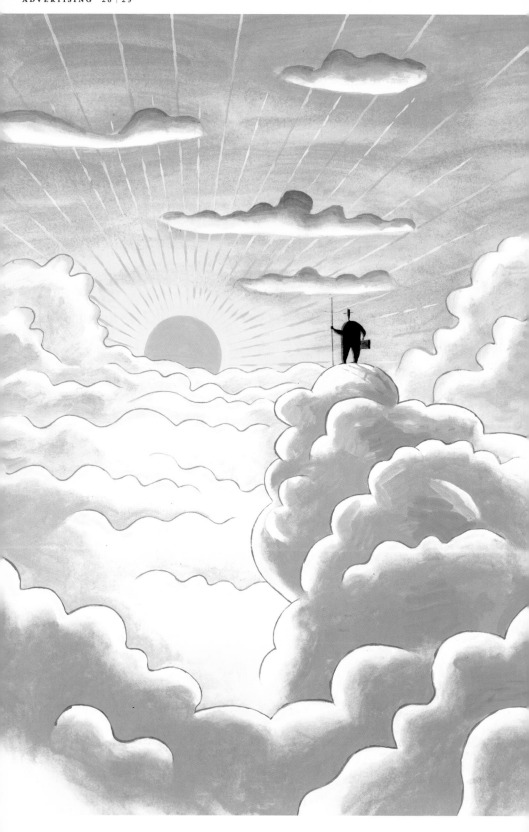

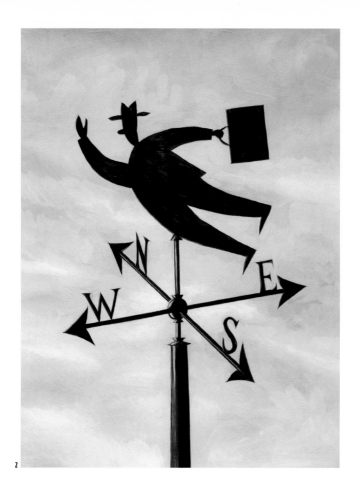

1-3 **ART DIRECTOR**:
Bob Barrie
ILLUSTRATOR:
Jeffrey Fisher
DESIGN AGENCY:
Fallon Minneapolis
CLIENT:
United Airlines

1 2

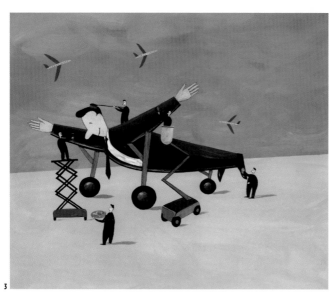

3

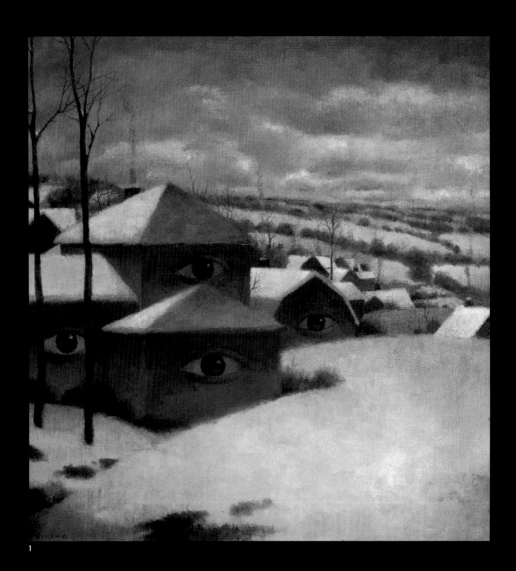

1

1 ART DIRECTOR:
Jasmine Lee
ILLUSTRATOR:
Brad Holland
CLIENT:
Penguin Putnam Inc.

2 ART DIRECTOR:
Ilkka Kärkkäinen
ILLUSTRATOR:
Pietari Posti
CLIENT:
Dynamo Advertising

The SNOBS

muriel Spark

70

Esquina de
y Calzada

Cuahutemozin
de Tlalpan

1925

1–5 EDITOR:
Arlette Remondi
ILLUSTRATOR:
Marina Sagona
CLIENT:
El Edizioni

2

3

4

5

1

4

5

1 DESIGNER:
 John Fulbrook III
 ILLUSTRATOR:
 Elvis Swift
 CLIENT:
 Simon & Schuster

2 ART DIRECTOR:
 Paul Buckley,
 Jasmine Lee
 DESIGNER:
 Paul Buckley
 ILLUSTRATOR:
 Mick Wiggins
 CLIENT:
 Penguin Classics

3 ART DIRECTOR:
 Paul Buckley,
 Jasmine Lee
 DESIGNER:
 Paul Buckley
 ILLUSTRATOR:
 Mick Wiggins
 CLIENT:
 Penguin Classics

4 ART DIRECTOR:
 Paul Buckley
 DESIGNER:
 Paul Buckley
 ILLUSTRATOR:
 Mick Wiggins
 CLIENT:
 Penguin

5 ART DIRECTOR:
 Paul Buckley,
 Jasmine Lee
 DESIGNER:
 Paul Buckley
 ILLUSTRATOR:
 Mick Wiggins
 CLIENT:
 Penguin Classics

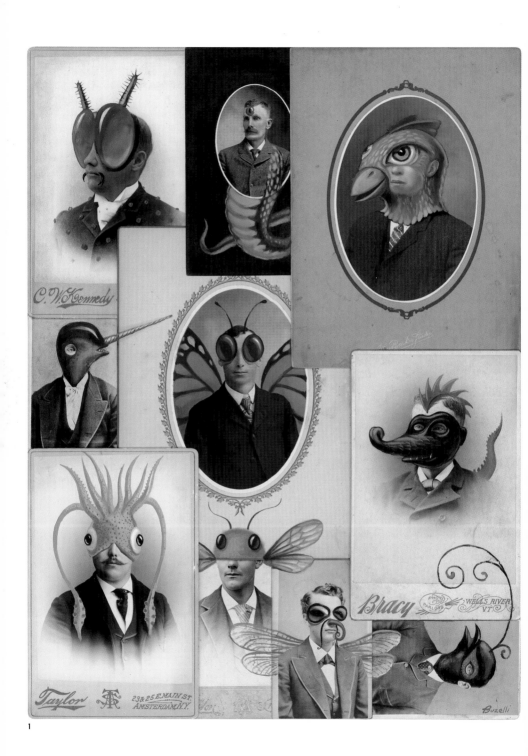

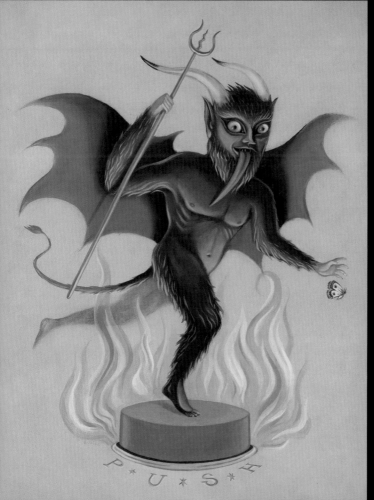

ILLUSTRATOR:
Chris Buzelli
CLIENT:
Global Custodian
Magazine

2 ART DIRECTOR:
SooJin Buzelli
DESIGNER:
Maynard Kay
ILLUSTRATOR:
Chris Buzelli
CLIENT:
Global Custodian
Magazine

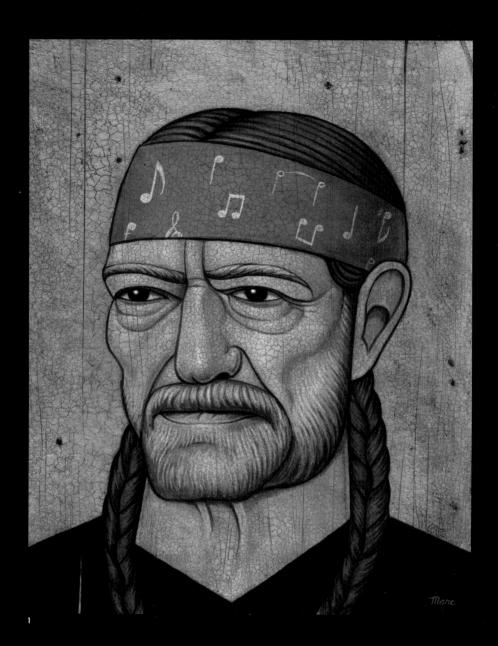

1

1 ART DIRECTOR:
TJ Tucker
ILLUSTRATOR:
Marc Burckhardt
CLIENT:
Texas Monthly

2 ART DIRECTOR:
Victoria Nightingale
ILLUSTRATOR:
Edel Rodriguez
CLIENT:
Reader's Digest

2

1

1-3 ART DIRECTOR:
Jenni Ohnstead
ILLUSTRATOR:
Jon Krause
CLIENT:
Vanderbilt University

4 ART DIRECTOR:
Angelica Steudel
ILLUSTRATOR:
*Jean-Philippe
Delhomme*
CLIENT:
*Architectural Digest
(France)*

4

1

2

3

4

1 **ART DIRECTOR:**
Ann Harvey
ILLUSTRATOR:
Marcos Chin
DESIGN FIRM:
Pace Communications
CLIENT:
Delta Sky

2 **ART DIRECTOR:**
Charles Hively
ILLUSTRATOR:
Marcos Chin
CLIENT:
3x3 Magazine

3 **ART DIRECTOR:**
Neva Tachkova
ILLUSTRATOR:
Pol Turgeon
CLIENT:
CIO Magazine

4 **ART DIRECTOR:**
Andrew Lee
ILLUSTRATOR:
Jonathan Burton
CLIENT:
*Financial Times
Magazine*

5 **ART DIRECTOR:**
Karen Player
ILLUSTRATOR:
Craig Frazier
DESIGN FIRM:
*Harvard Business School
Publications*
CLIENT:
*On Point (Harvard
Business Review)*

5

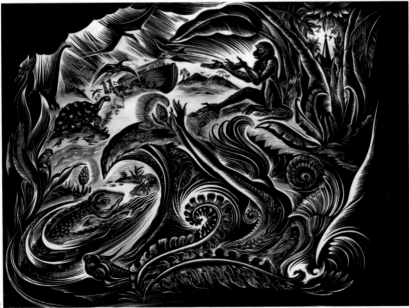

1

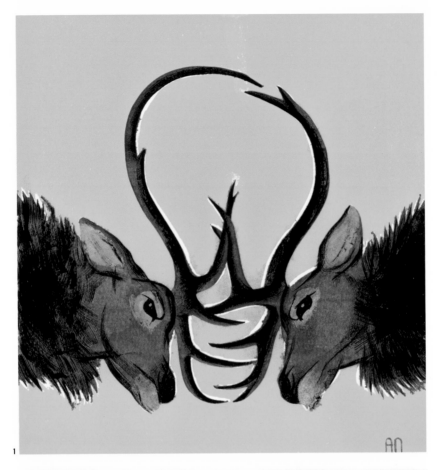

2

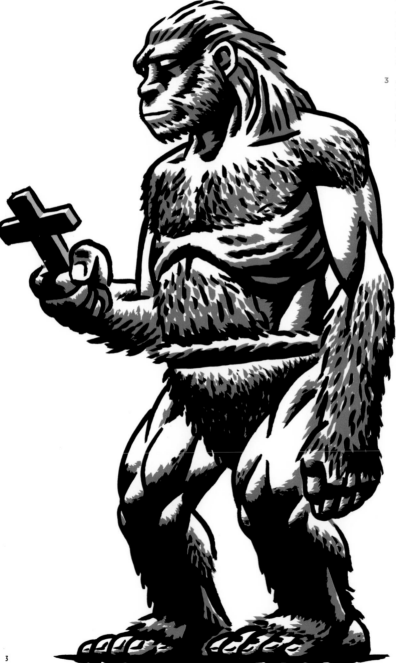

1 ART DIRECTOR:
Lou Vega
ILLUSTRATOR:
Alex Nabaum
CLIENT:
INC. Magazine

2 ART DIRECTOR:
Rob Wilson
DESIGNER:
Rob Wilson
ILLUSTRATOR:
Cathie Bleck
CLIENT:
Playboy Magazine

3 ART DIRECTOR:
TJ Tucker
ILLUSTRATOR:
Douglas Fraser
CLIENT:
Texas Monthly

3

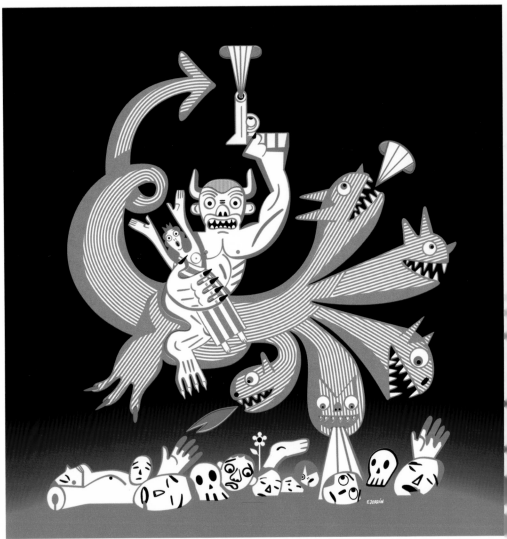

1

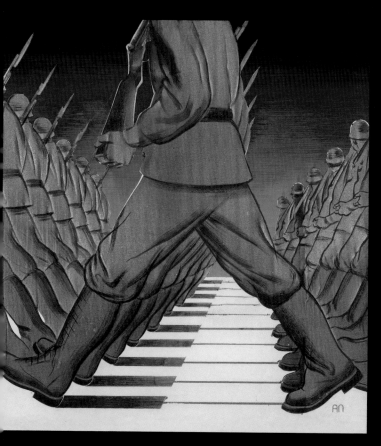

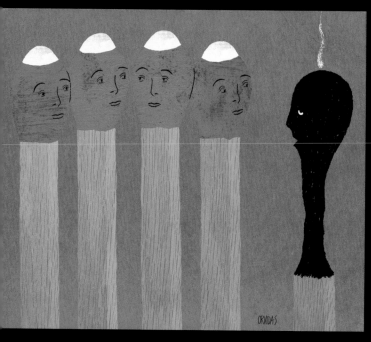

1 **ART DIRECTOR**:
Fabricio Vanden Broek,
Julio Trujillo
ILLUSTRATOR:
Federico Jordan
CLIENT:
Letras Libres Magazine

2 **ART DIRECTOR**:
Wesley Bausmith
ILLUSTRATOR:
Alex Nabaum
CLIENT:
Los Angeles Times

3 **ART DIRECTOR**:
Emily Borden
ILLUSTRATOR:
Ken Orvidas
DESIGN AGENCY:
Curtco Publishing
CLIENT:
Worth Magazine

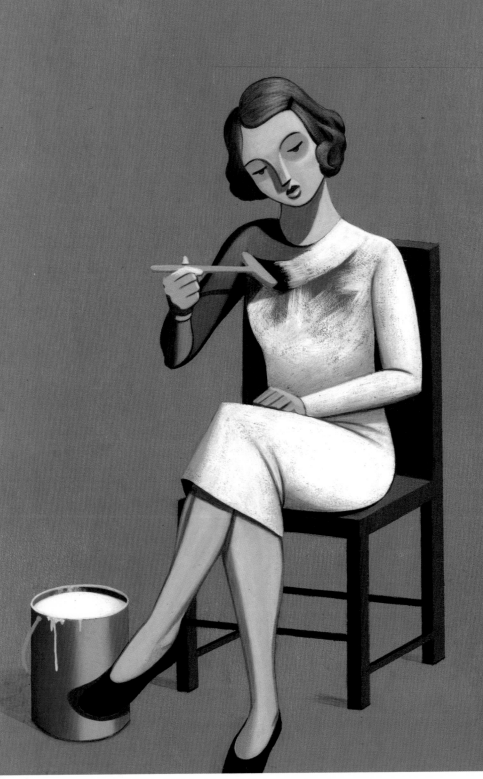

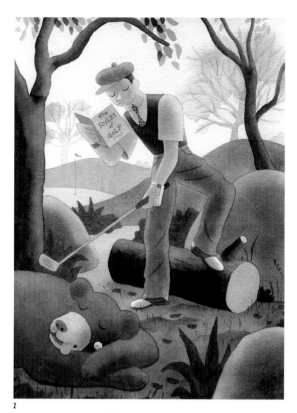

1 ART DIRECTOR:
Michelle McCorkle
ILLUSTRATOR:
Jon Krause
CLIENT:
Brio Magazine

2 ART DIRECTOR:
Lori Cusick
ILLUSTRATOR:
Greg Clarke
CLIENT:
Private Clubs Magazine

3 ART DIRECTOR:
Dean Abatemarco
ART DIRECTOR:
Linda Rubes
ILLUSTRATOR:
Eddie Guy
CLIENT:
Fortune

2

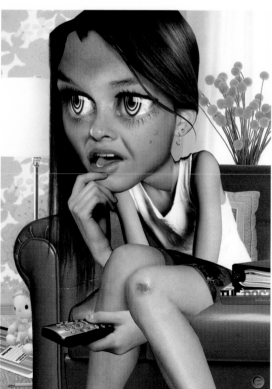

3

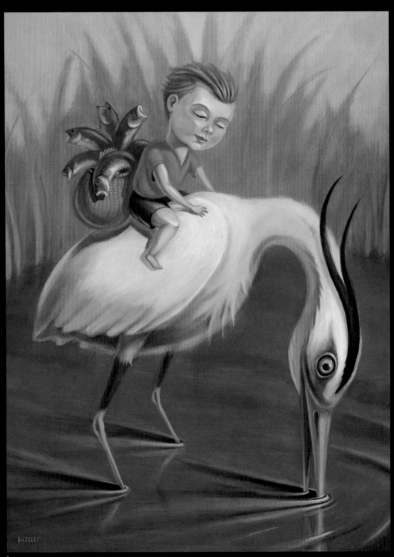

1

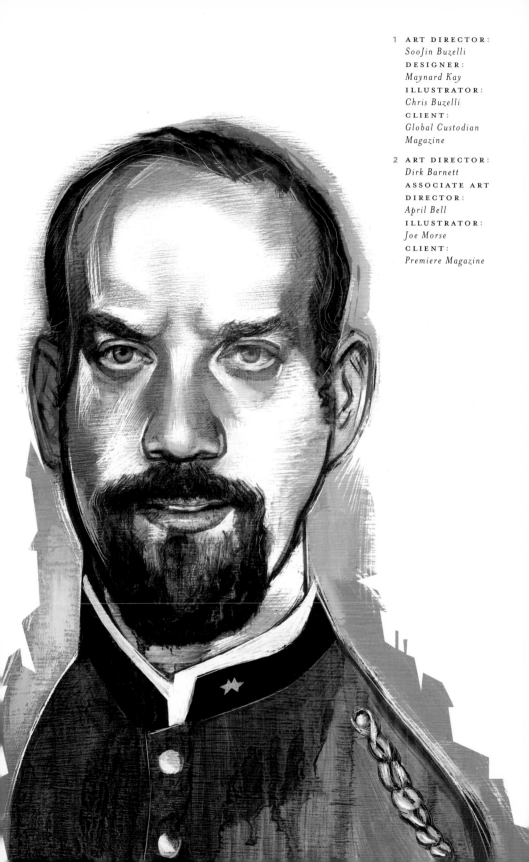

1 ART DIRECTOR:
SooJin Buzelli
DESIGNER:
Maynard Kay
ILLUSTRATOR:
Chris Buzelli
CLIENT:
*Global Custodian
Magazine*

2 ART DIRECTOR:
Dirk Barnett
ASSOCIATE ART
DIRECTOR:
April Bell
ILLUSTRATOR:
Joe Morse
CLIENT:
Premiere Magazine

1

2

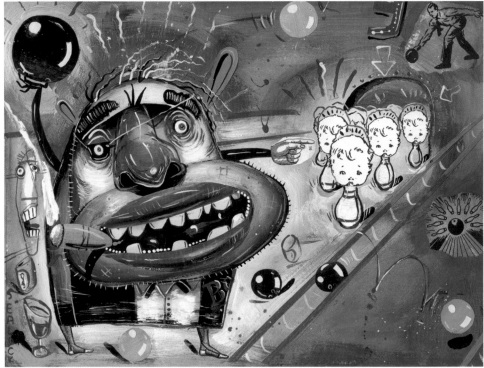

3

4

5

1 **ART DIRECTOR:**
David Harris
ILLUSTRATOR:
Brad Holland
CLIENT:
Vanity Fair

2 **DESIGN DIRECTOR:**
Robert Newman
ILLUSTRATOR:
Eddie Guy
CLIENT:
Reader's Digest

3 **ART DIRECTOR:**
Tom Carlson
DESIGNER:
Tom Carlson
ILLUSTRATOR:
Rick Sealock
CLIENT:
Riverfront Times

4 **ART DIRECTOR:**
Luisa Rino
ILLUSTRATOR:
Andrew Zbihlyj
CLIENT:
Nuvo Magazine

5 **ART DIRECTOR:**
Eleanor Williamson
DESIGNER:
Shennon Murray
ILLUSTRATOR:
Brian Cairns
CLIENT:
Ski Magazine

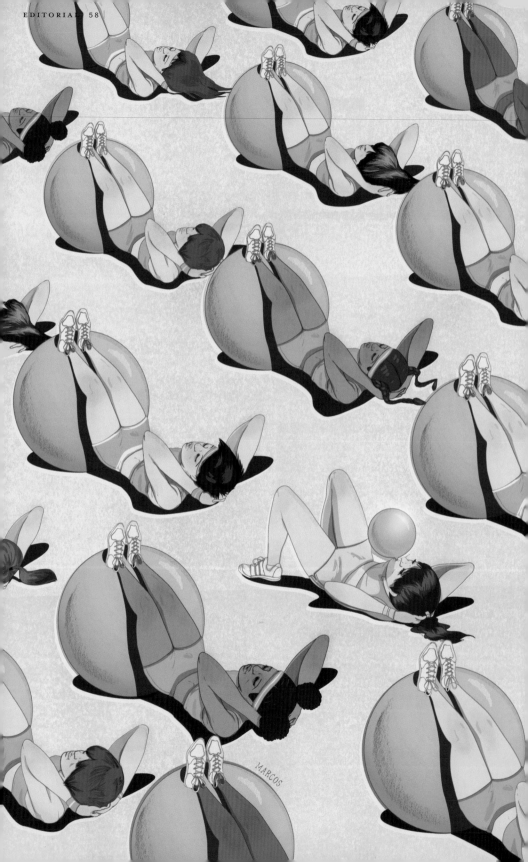

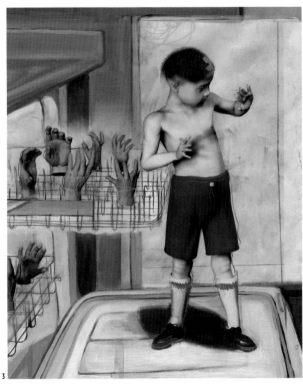

1 **ART DIRECTOR:**
Rachel Volpe
ILLUSTRATOR:
Marcos Chin
CLIENT:
Hers

2 **ART DIRECTOR:**
SooJin Buzelli
ILLUSTRATOR:
Adam McCauley
CLIENT:
Plan Sponsor Magazine

3 **ART DIRECTOR:**
Arem Duplessis
DESIGNER:
Jeff Glendenning
ILLUSTRATOR:
Erik Sandberg
CLIENT:
The New York Times Magazine

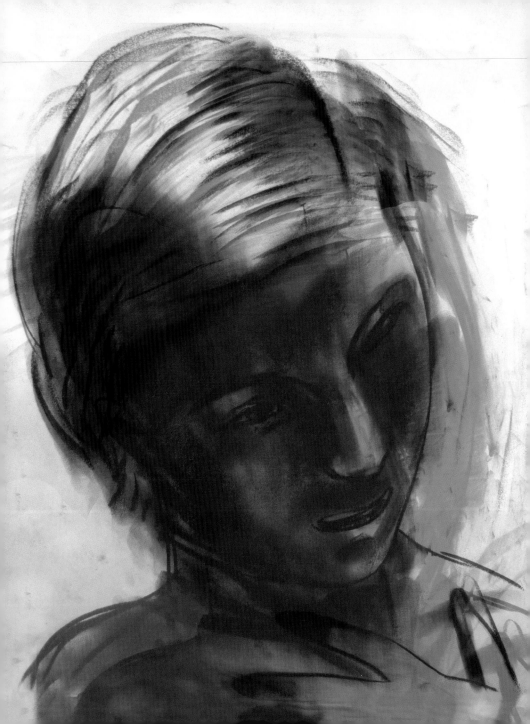

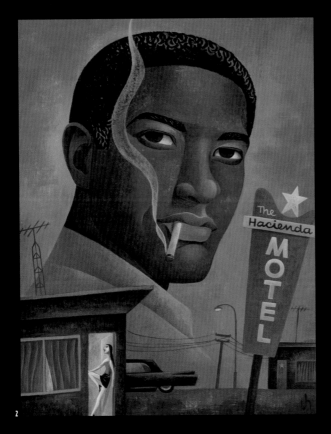

1 **ART DIRECTOR:**
Dorothy Yule
DESIGNER:
Dorothy Yule
ILLUSTRATOR:
Vivienne Flesher
CLIENT:
Chronicle

2 **ART DIRECTOR:**
Joe Kimberling
ILLUSTRATOR:
Jody Hewgill
CLIENT:
Los Angeles Magazine

3 **ART DIRECTOR:**
Joe Newton
DESIGNER:
Joe Newton
ILLUSTRATOR:
Olaf Hajek
CLIENT:
Rolling Stone

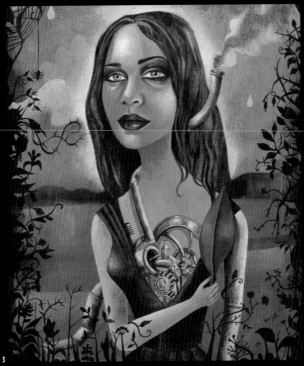

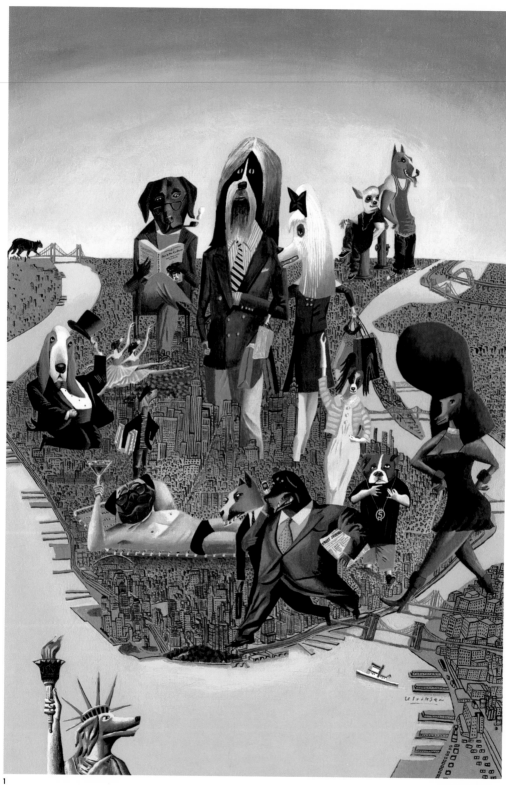

1

BEJAR

The King

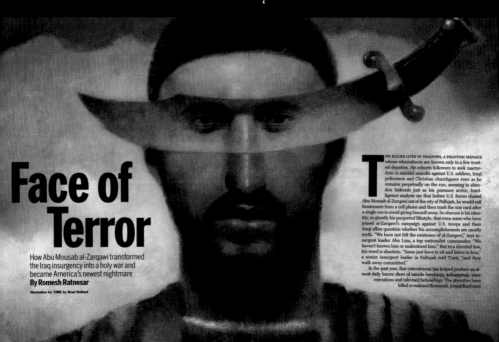

Face of Terror

How Abu Mousab al-Zarqawi transformed
the Iraq insurgency into a holy war and
became America's newest nightmare
By Romesh Ratnesar

Illustration for TIME by Brad Holland

THE KILLER LIVES IN SHADOWS, A PHANTOM MENACE
whose whereabouts are known only to a few trust-
ed deputies. He exhorts followers to seek martyr-
dom in suicidal assaults against U.S. soldiers, Iraqi
policemen and Christian churchgoers even as he
remains perpetually on the run, seeming to aban-
don hideouts just as his pursuers arrive. Intel-
ligence analysts say that before U.S. forces chased
Abu Mousab al-Zarqawi out of the city of Fallujah, he would call
lieutenants from a cell phone and then trash the sim card after
a single use to avoid giving himself away. So obscure is his iden-
tity, so ghostly his purported lifestyle, that even some who have
joined al-Zarqawi's campaign against U.S. troops and their
Iraqi allies question whether his accomplishments are mostly
myth. "We have not felt the existence of al-Zarqawi," says in-
surgent leader Abu Lina, a top nationalist commander. "We
haven't known him or understood him." But to a devoted few,
his word is absolute. "Some just have to sit and listen to him,"
a senior insurgent leader in Fallujah told TIME, "and they
walk away committed."

In the past year, that commitment has helped produce an al-
most daily horror show of suicide bombings, kidnappings, mass
executions and televised beheadings. The atrocities have
killed or maimed thousands, jeopardized next

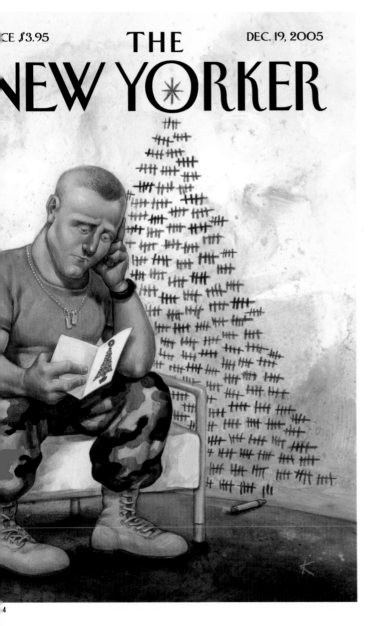

1 ART DIRECTOR:
Maryann Salvato
ILLUSTRATOR:
Daniel Bejar
CLIENT:
Money Magazine

2 ART DIRECTOR:
Hudd Byard
DESIGNER:
Hudd Byard
ILLUSTRATOR:
Anita Kunz
CLIENT:
Memphis Magazine

3 ART DIRECTOR:
Arthur Hockstein,
Cynthia Hoffman
ILLUSTRATOR:
Brad Holland
CLIENT:
Time Magazine

4 ART DIRECTOR:
Françoise Mouly
DESIGNER:
Françoise Mouly
ILLUSTRATOR:
Anita Kunz
CLIENT:
The New Yorker

1

1 ART DIRECTOR:
Michael Hogue
ILLUSTRATOR:
Joe Morse
CLIENT:
*The Dallas Morning
News*

2 ART DIRECTOR:
Stacey D. Clarkson
ILLUSTRATOR:
Andrew Zbihlyj
CLIENT:
Harper's Magazine

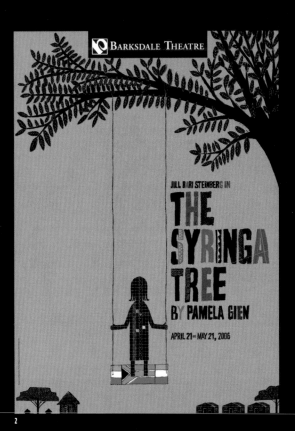

1 ILLUSTRATOR:
Beppe Giacobbe
DESIGN FIRM:
San Pelligrino
CLIENT:
San Pelligrino

2 ART DIRECTOR:
Sara Marden,
Kate Carpenter
DESIGNER:
Robert Meganck
ILLUSTRATOR:
Robert Meganck
DESIGN FIRM:
Communication
Design, Inc.
CLIENT:
Barksdale Theatre

The Illustration
Department of
Parsons School of
Design Presents

An Evening With

MIKE MIGNOLA

Creator of *Hellboy*
and the 2005 Parsons
Modern Master of Illustration

March 3rd, 2005
5:30 PM
Swayduck Auditorium
65 5th Avenue

Book Signing to Follow
www.parsons.edu/illustration

Design and Illustration Les Kanturek

2

3

4

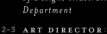

of Design, University
Department

2-3 ART DIRECTOR:
Sandy Kaufman
ILLUSTRATOR:
Jeffrey Fisher
CLIENT:
Columbia University

4 ILLUSTRATOR:
Travis Lampe
CLIENT:
Moody Buddha

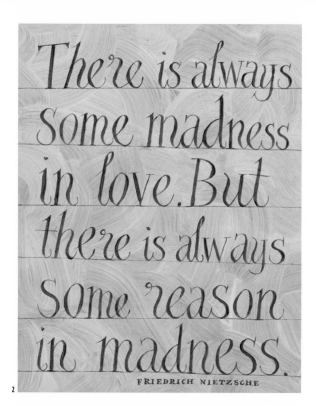

There is always some madness in love. But there is always some reason in madness.

FRIEDRICH NIETZSCHE

1 ART DIRECTOR:
 Anders Lindholm
 ILLUSTRATOR:
 Anders Lindholm
 DESIGN FIRM:
 Alprod
 CLIENT:
 Formas

2 EDITOR:
 Carey Jones
 DESIGNER:
 Kristen Hewitt
 ILLUSTRATOR:
 Jeffrey Fisher
 CLIENT:
 Chronicle Giftworks

3 ART DIRECTOR:
 Vivienne Flesher
 ILLUSTRATOR:
 Vivienne Flesher
 CLIENT:
 Associazione Culturale
 Teatrio

1-5 DESIGNER:
Guido Scarabottolo
ILLUSTRATOR:
Guido Scarabottolo
DESIGN FIRM:
Arcoquattro
CLIENT:
Arcoquattro

4 5

2

1 ART DIRECTOR:
Tagie Tate Perez
ILLUSTRATOR:
Ken Orvidas
DESIGN FIRM:
SeeSeeEye Design
CLIENT:
Neenah Paper Company

2 ART DIRECTOR:
Jason Smith
DESIGNER:
Robert Meganck
ILLUSTRATOR:
Robert Meganck
DESIGN FIRM:
*Communication
Design, Inc.*
CLIENT:
Richmond Magazine

2 ART DIRECTOR:
Mark Shaw,
Anne Yeckley Todd
ILLUSTRATOR:
Pol Turgeon
CLIENT:
American Media

1-5 ILLUSTRATOR:
Marc Lalumière,
Rielle Lévesque
CLIENT:
Canadian Museum of
Nature, Ottawa

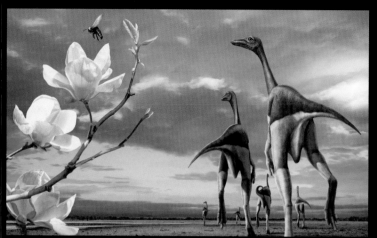

3

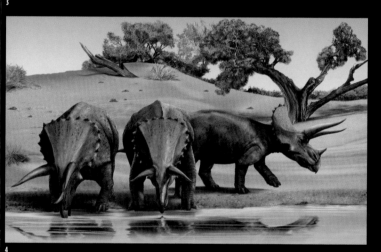

4

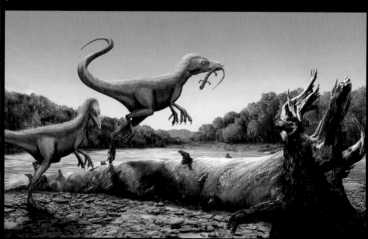

5

1

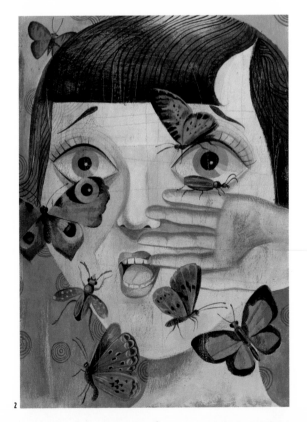

2

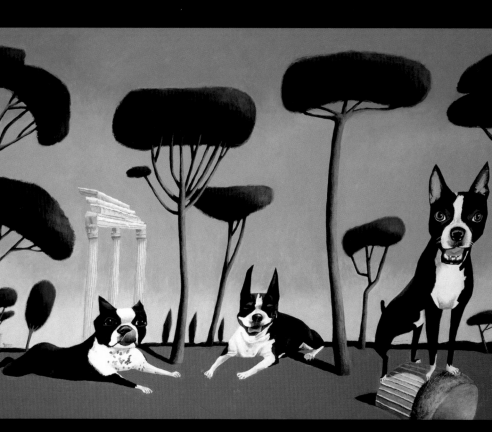

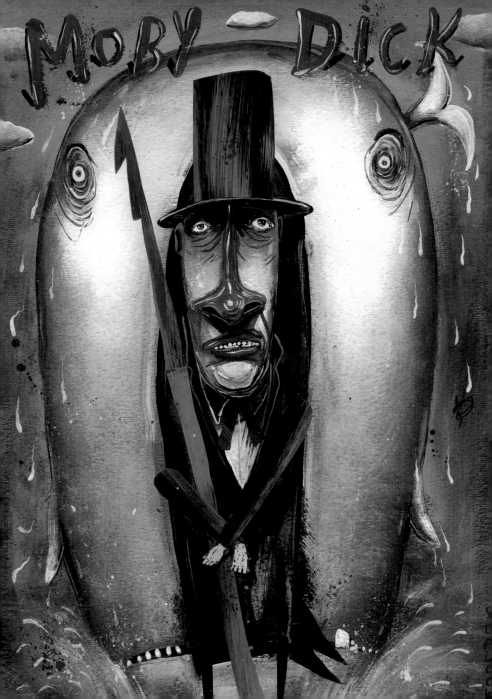

1 TITLE:
Moby Dick
ILLUSTRATOR:
Rick Sealock

2-6 TITLE:
Lisbon Portraits Series
ILLUSTRATOR:
Pierre Pratt

2

3

4

5

6

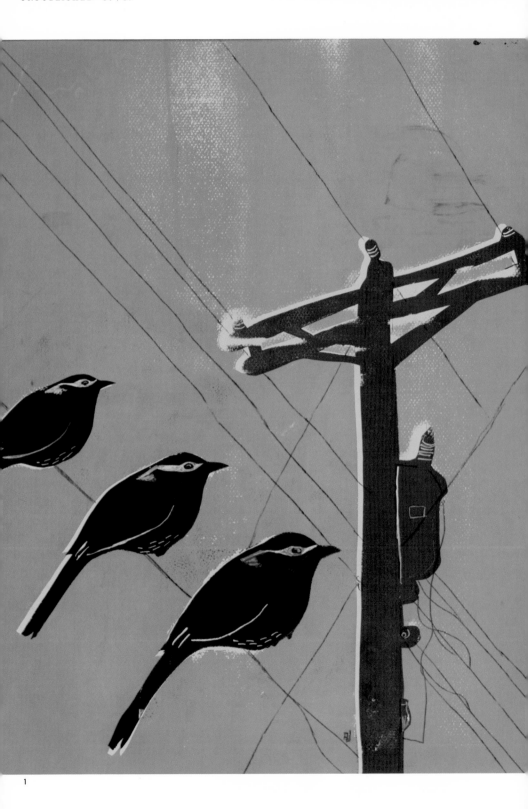

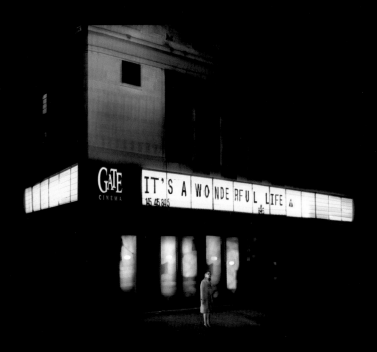

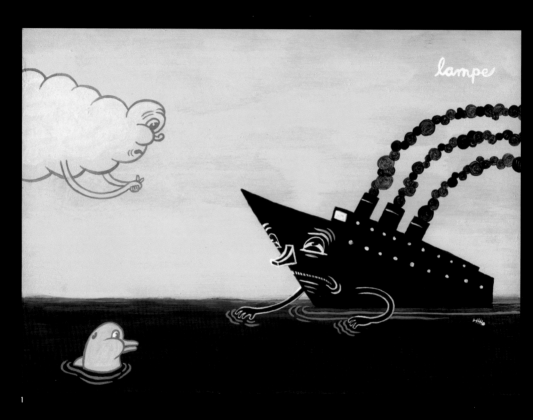

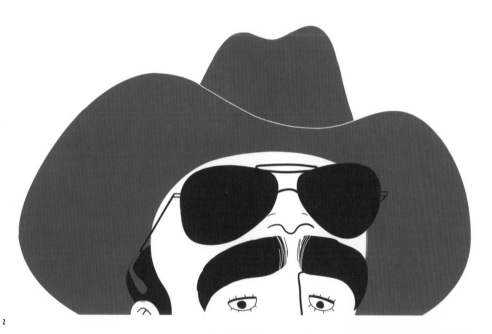

2

3

4

5

sugar

PLAIN

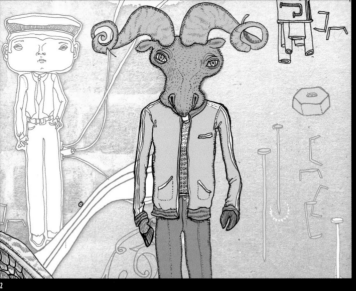

2

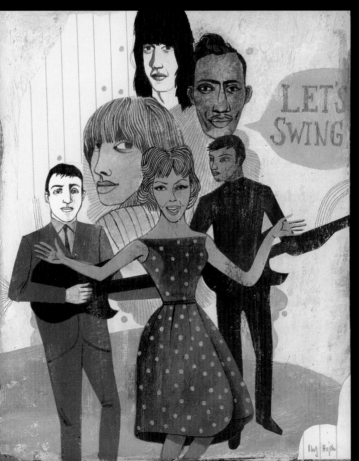

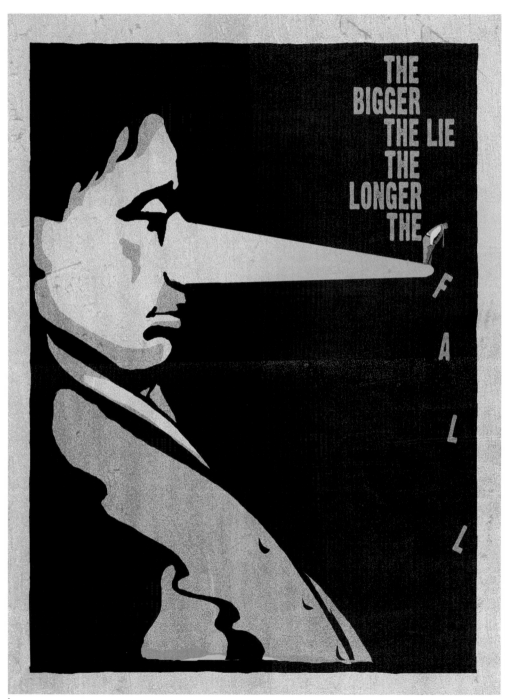

2

2

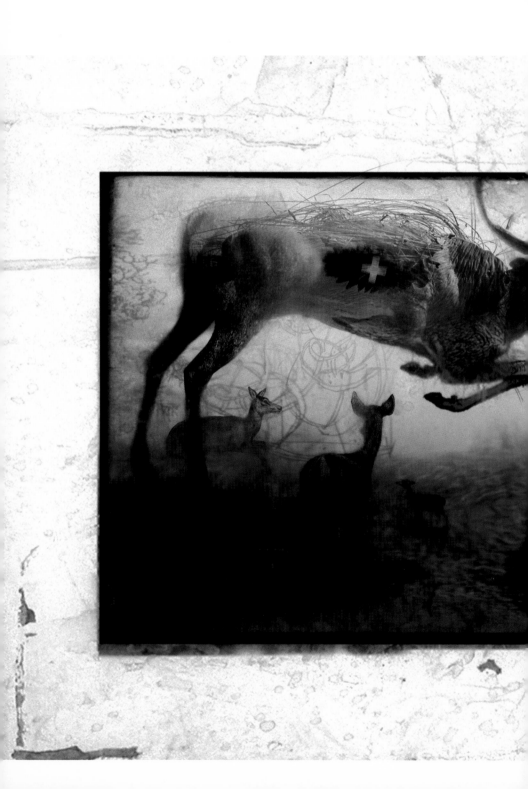

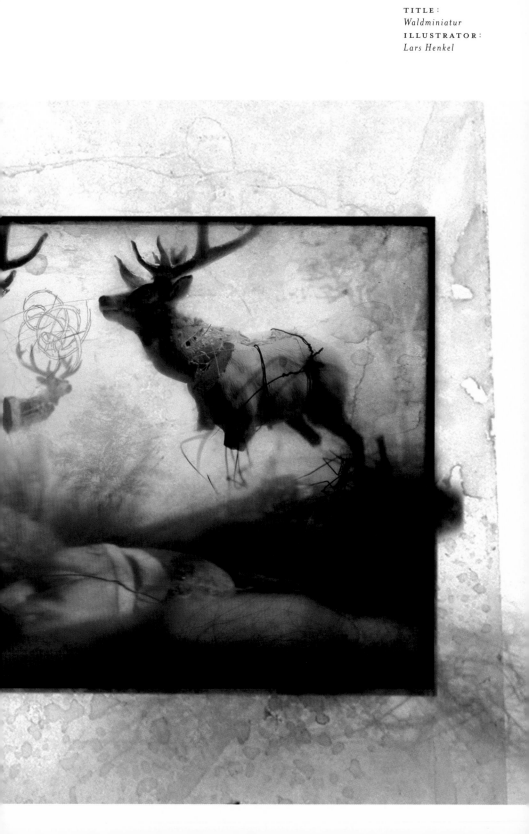

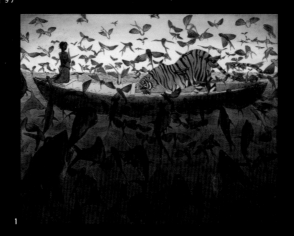

1

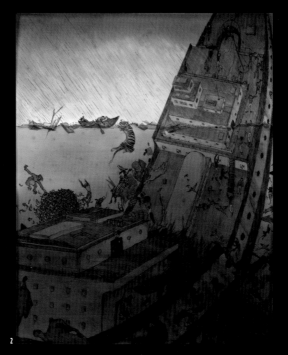

2

3

4

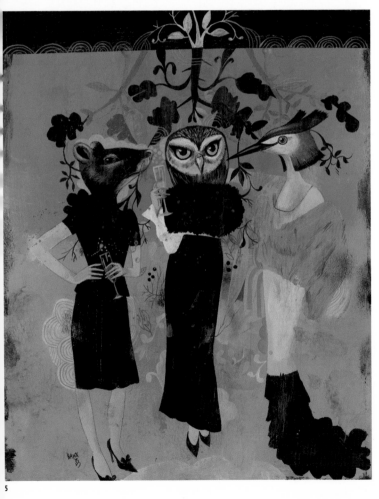

5

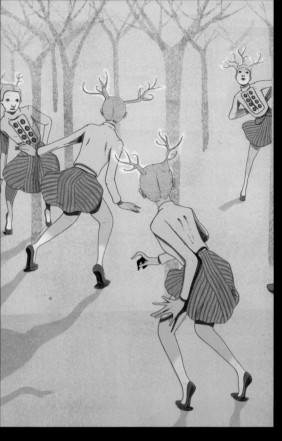

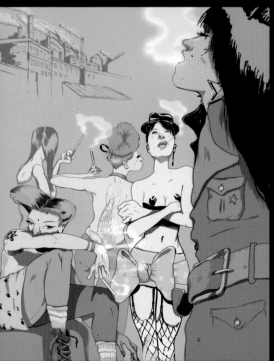

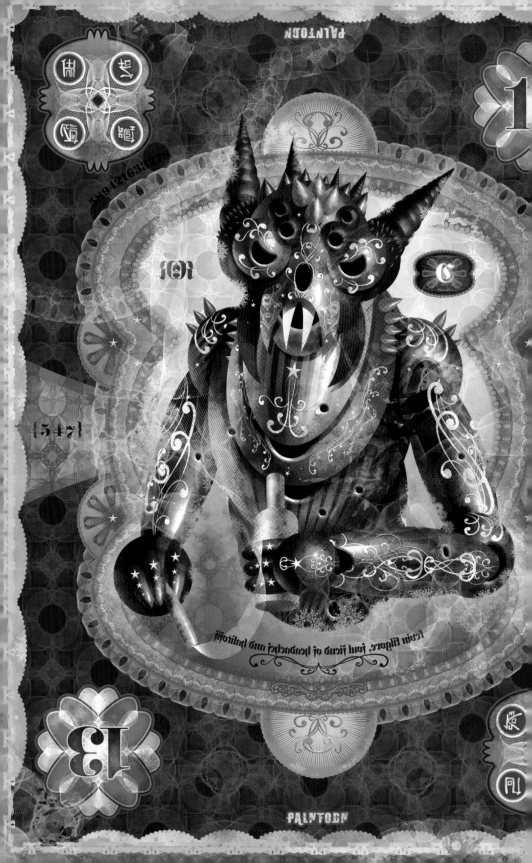

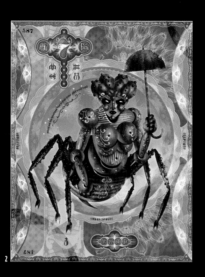

1-4 TITLE:
Monster Series
ILLUSTRATO
Kristian Olson

2

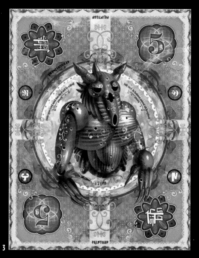

3

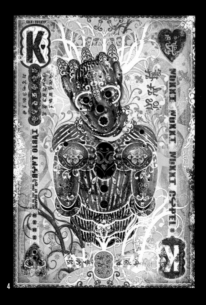

1 4

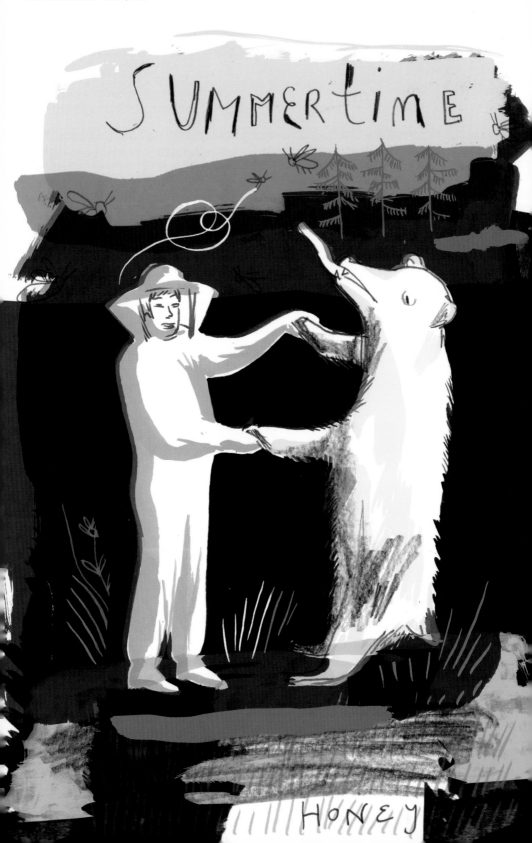

1

1 **TITLE:**
Honey-Summer
ILLUSTRATOR:
Monika Aichele

2 **TITLE:**
Gillian Welch
ILLUSTRATOR:
Julia Breckenreid

3 **TITLE:**
American Thoroughbred
ILLUSTRATOR:
Marc Burckhardt

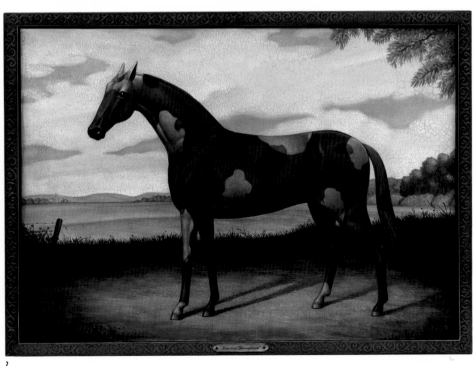

2

2

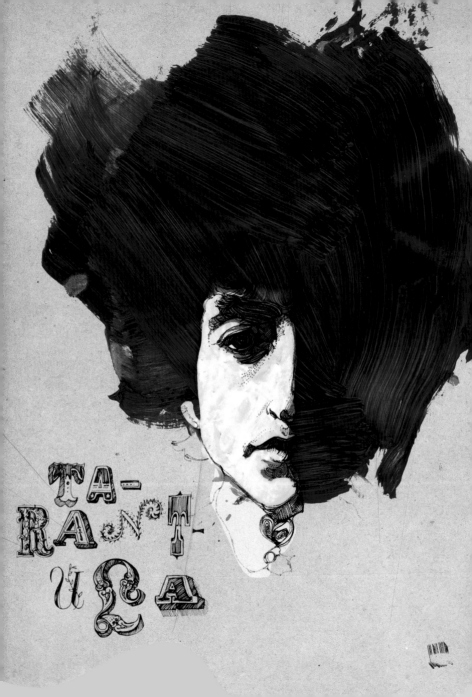

1 **TITLE:**
 Bob Dylan Tarantula
 ILLUSTRATOR:
 Greg Stevenson

2 **TITLE:**
 Blab Painting
 ILLUSTRATOR:
 Greg Clarke

3 **TITLE:**
 I Won't See it
 ILLUSTRATOR:
 Eric Field

2

3

TITLE:
Gustav Katz
ILLUSTRATOR:
Greg Clarke

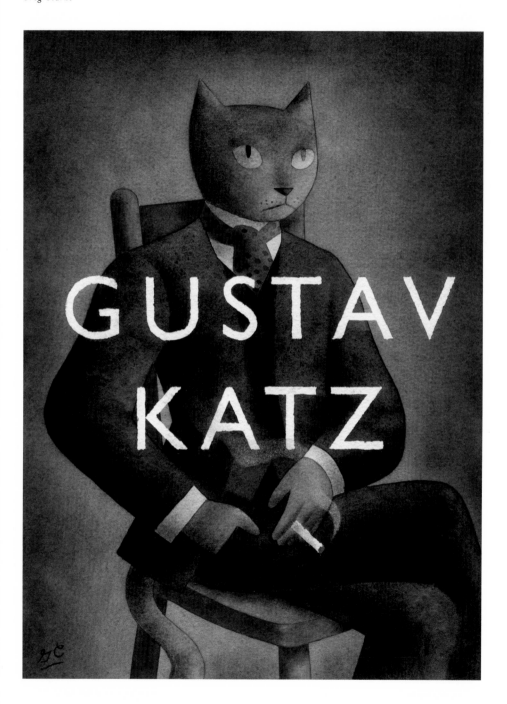

THREE BY THREE CHILDREN'S BOOKS SHOW

Best of Show
PAGE 110

Gold
PAGE 112

Silver
PAGE 114

Bronze
PAGE 117

Merit
PAGE 119

STANLEY

Goes for a Drive

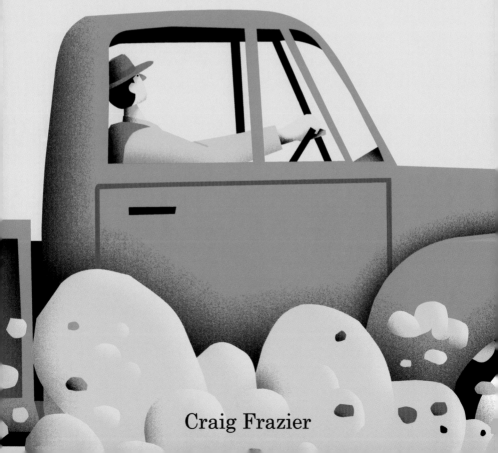

Craig Frazier

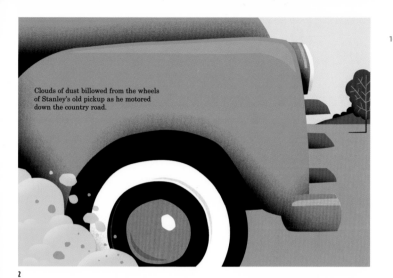

Clouds of dust billowed from the wheels of Stanley's old pickup as he motored down the country road.

BEST OF SHOW

1–4 ILLUSTRATOR:
Craig Frazier
AUTHOR:
Craig Frazier
EDITOR:
Victoria Rock
ART DIRECTOR:
Craig Frazier
PUBLISHER:
Chronicle Books

2

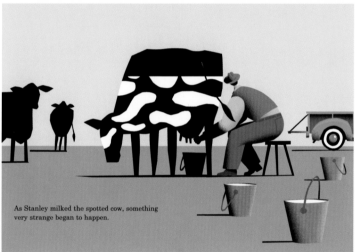

As Stanley milked the spotted cow, something very strange began to happen.

3

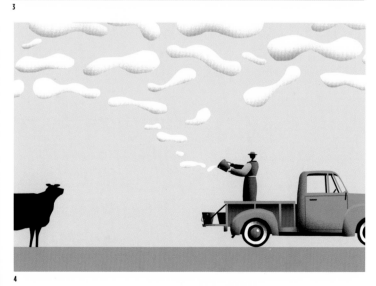

4

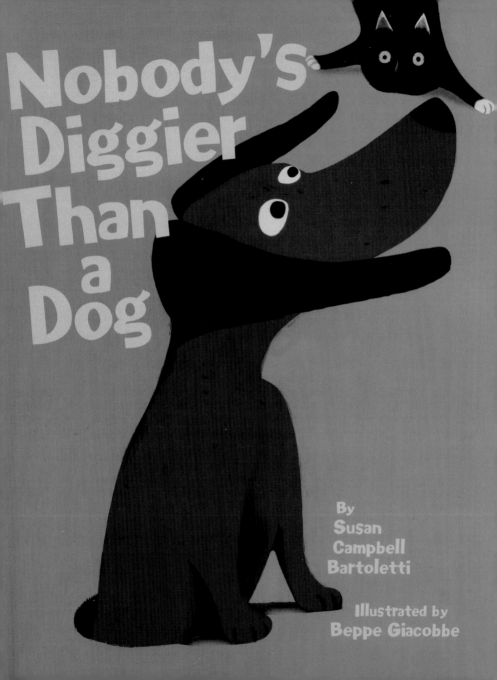

Nobody's Diggier Than a Dog

By
Susan
Campbell
Bartoletti

Illustrated by
Beppe Giacobbe

GOLD

1-4 ILLUSTRATOR:
Beppe Giacobbe
AUTHOR:
*Susan Campbell
Bartoletti*
PUBLISHER:
*Hyperion Books for
Children*

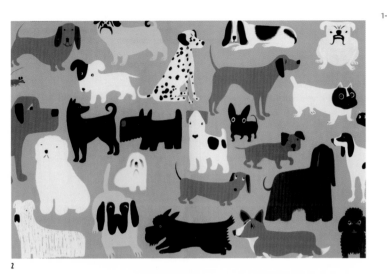

2

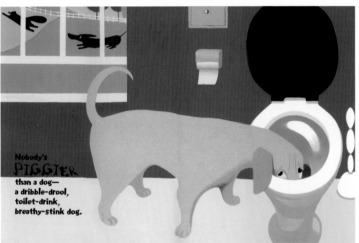

Nobody's
PIGGIER
than a dog—
a dribble-drool,
toilet-drink,
breathy-stink dog.

3

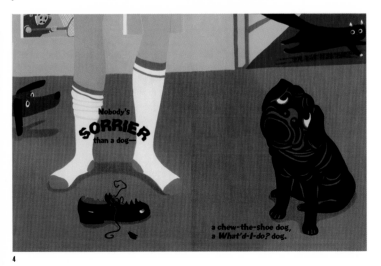

Nobody's
SORRIER
than a dog—

a chew-the-shoe dog,
a *What'd-I-do?* dog.

4

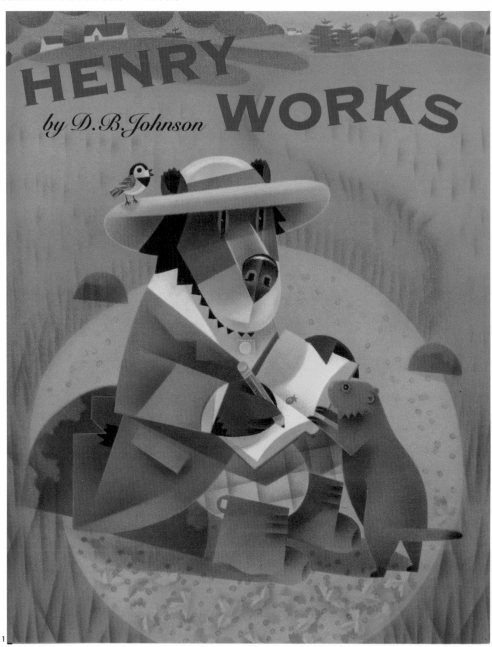

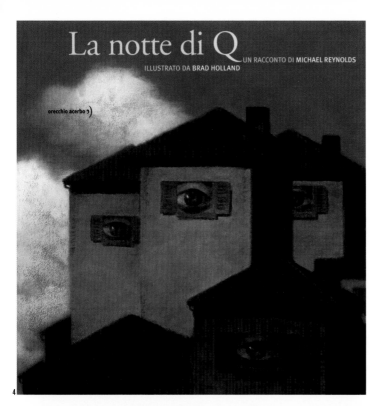

4

5

6

SILVER

1-3 ILLUSTRATOR:
D.B. Johnson
AUTHOR:
D.B. Johnson
EDITOR:
Margaret Raymo
ART DIRECTOR:
Shiela Smallwood
PUBLISHER:
Houghton Mifflin Co.

4-6 SILVER
ILLUSTRATOR:
Brad Holland
AUTHOR:
Michael Reynolds
ART DIRECTOR:
*Paola Quintavalle,
Fausta Orecchio*
PUBLISHER:
Orecchio Acerbo

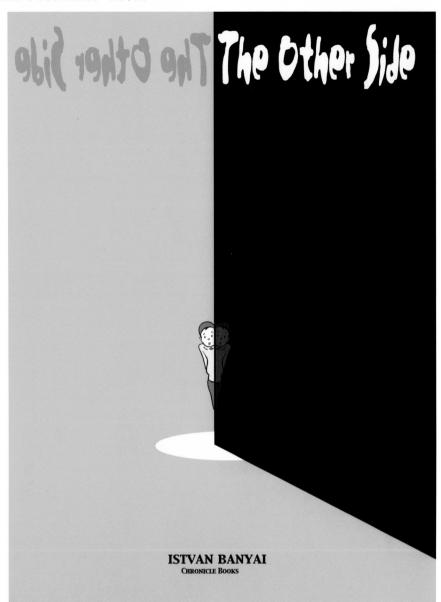

1

2

3

קורני צ'וקובסקי

זבובה-נמזומבה

איורים: נטלי פינגלוב

זבובה, זבובה נמזומבה
עם כּסֶפּוֹ הַמֻזהַב!
זבובה בַּשָּׂדֶה יָצְאָה,
וּמַטְבֵּעַ חַיִּ
סָצְאָה.

גַם קוֹפְץ טוֹ צְעַר
בַּתֵּבֶל טַרְוֵז!

נֶשׂמָחָה כֹּה - בְּוַלָּה!
מְתַחַתֶּנֶת זבוב
עַם צַמֵּץ וַעַז

גִּזוֹקִים - אִכּרם
תֻשׁבִּים וַעֲשׁירִים
קוֹפְּצִים בָּתֹנְצִים
וְתוֹקְדִים עַם פַּרְפַּרִים

שׁוּק הַכַּרְמֶל

מִהֲרָה לָשׂיחַ בַּכְּפַר
מֶקְצָרָה עַם סְמוֹצֶר!

"הֵי, תָּבוֹאוּ פַּשְׁפָּשִׁים,
אַכָּבֵר אֶתְכֶם
בַּתַּוְ!"

Marei Schweitzer

Notizen
vom
Käptn's Dinner

BAjAZZOVERLAG

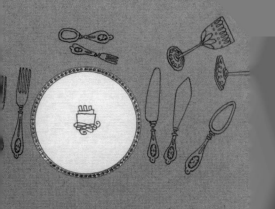

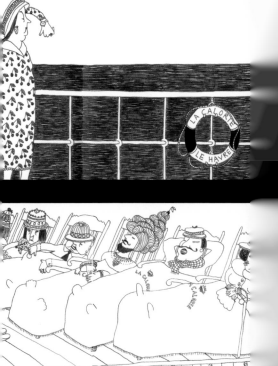

BRONZE

1-3 ILLUSTRATOR:
Marei Schweitzer
AUTHOR:
Marei Schweitzer
EDITOR:
Thomas Minssen
ART DIRECTOR:
Marei Schweitzer
PUBLISHER:
Bajazzo Verlag

4 ILLUSTRATOR:
James Yang
AUTHOR:
James Yang
EDITOR:
Richard Jackson
ART DIRECTOR:
Polly Kanevesky
PUBLISHER:
Atheneum
IMPRINT:
A Richard Jackson Book

5 ILLUSTRATOR:
Robert Neubecker
AUTHOR:
Robert Neubecker
EDITOR:
Summer Laurie
ART DIRECTOR:
Summer Laurie
PUBLISHER:
Ten Speed Press
IMPRINT:
Tricycle Press

4

5

1

2

3

4

5

1 ILLUSTRATOR:
Judith Drews
AUTHOR:
Judith Drews
EDITOR:
Judith Drews
PUBLISHER:
Judith Drews

2 ILLUSTRATOR:
Lena Sjoberg
AUTHOR:
Lena Sjoberg
EDITOR:
Moa Brunnberg,
Ulrika Caperius
ART DIRECTOR:
Lena Sjoberg
PUBLISHER:
Eriksson & Lindgren

3 ILLUSTRATOR:
Sarajo Frieden
AUTHOR:
Anjali Banerjee
ART DIRECTOR:
Marci Senders
PUBLISHER:
Random House
IMPRINT:
KDD Young Readers

4 ILLUSTRATOR:
Brad Holland
AUTHOR:
Jon Berkely
ART DIRECTOR:
Marieke Woortman
PUBLISHER:
Van Goor/Unieboek BV

5 ILLUSTRATOR:
Brad Holland
AUTHOR:
Jon Berkely
ART DIRECTOR:
Marieke Woortman
PUBLISHER:
Van Goor/Unieboek BV

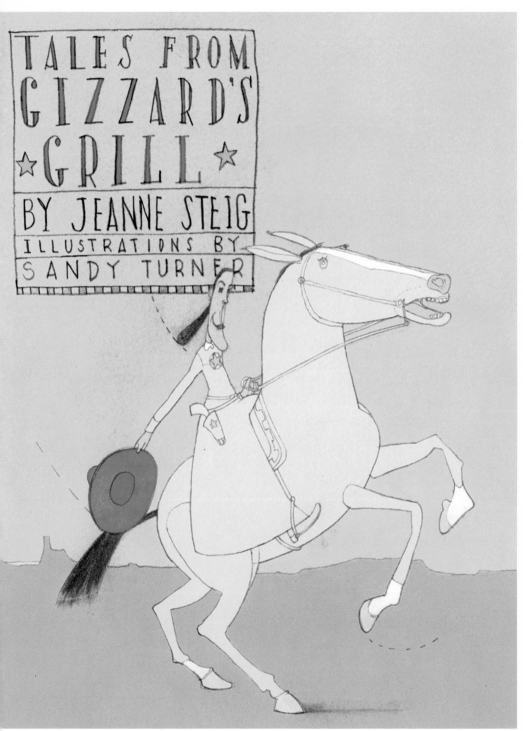

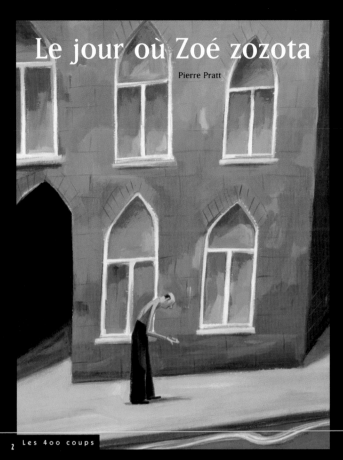

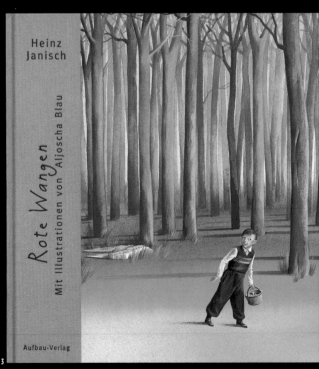

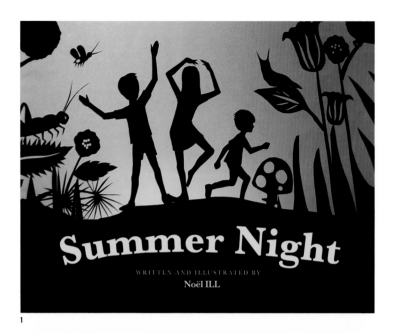

1

Summer Night
WRITTEN AND ILLUSTRATED BY
Noël ILL

MR. MAXWELL'S MOUSE

Frank Asch and Devin Asch

2

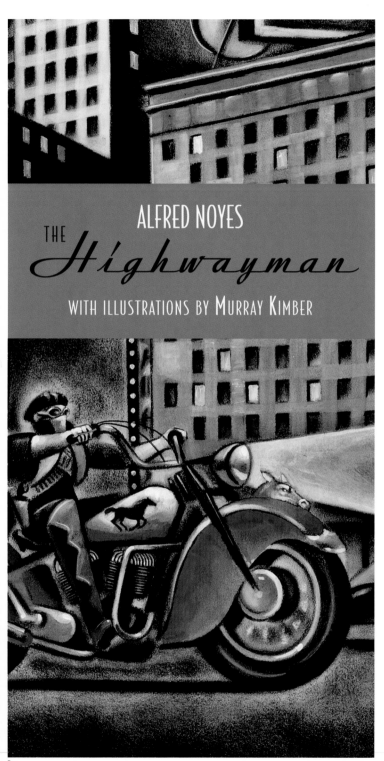

ALFRED NOYES

THE *Highwayman*

WITH ILLUSTRATIONS BY MURRAY KIMBER

1 ILLUSTRATOR:
Noël Ill
AUTHOR:
Noël Ill
EDITORS:
Esther Watson,
Mark Todd

2 ILLUSTRATOR:
Devin Asch
AUTHOR:
Frank Asch
EDITOR:
Tara Walker
ART DIRECTOR:
Marie Bartholomew
DESIGNER:
Karen Powers
publisher:
Kids Can Press

2 ILLUSTRATOR:
Murray Kimber
AUTHOR:
Alfred Noyes
EDITOR:
Tara Walker
ART DIRECTOR:
Marie Bartholomew
DESIGNER:
Karen Powers
PUBLISHER:
Kids Can Press

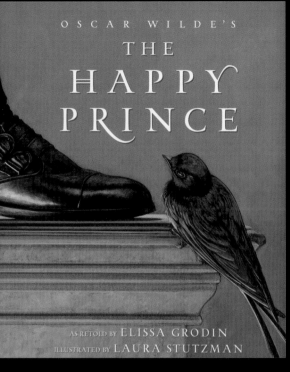

1 ILLUSTRATOR:
Jeffrey Fisher
AUTHOR:
Jeffrey Fisher
EDITOR:
Victoria Arms
PUBLISHER:
Bloomsbury Children's
Books

2 ILLUSTRATOR:
Laura Stutzman
AUTHORS:
Alissa Grodin, Oscar
Wilde
EDITOR:
Barbara McNally
ART DIRECTOR:
Jennifer Bacheller
PUBLISHER:
Thomson/Gale
IMPRINT:
Sleeping Bear Press

3 ILLUSTRATOR:
Carin Berger
AUTHOR:
Carin Berger
EDITOR:
Victoria Rock
ART DIRECTORS:
Sara Gillingham,
Carin Berger
PUBLISHER:
Chronicle Books

ILLUSTRATOR:
Craig Frazier
AUTHOR:
Craig Frazier
EDITOR:
Victoria Rock
ART DIRECTOR:
Craig Frazier
PUBLISHER:
Chronicle Books

THREE BY THREE STUDENT SHOW

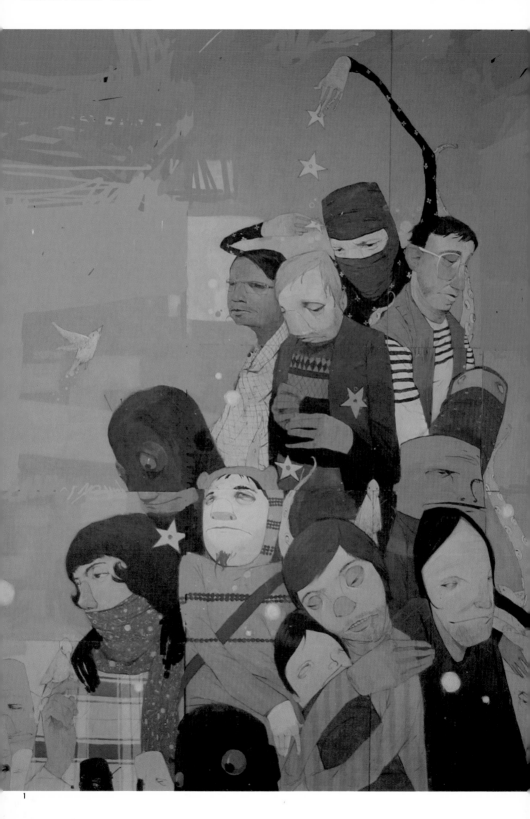

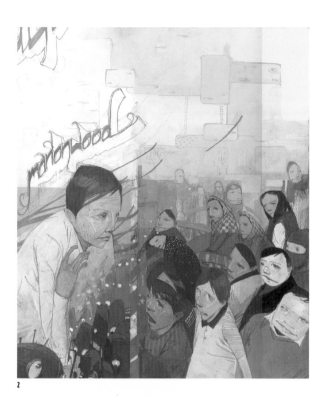

2

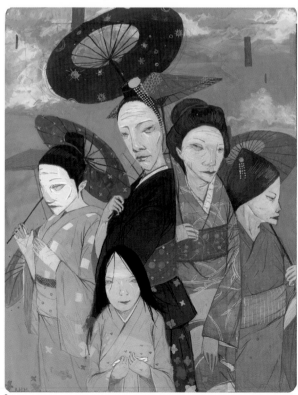

3

BEST OF SHOW
1 *Andrew Hem*
 INSTRUCTOR:
 Jim Salvati
 INSTITUTION:
 *Art Center College of
 Design*

GOLD
2 *Andrew Hem*
 INSTRUCTOR:
 Jim Salvati
 INSTITUTION:
 *Art Center College of
 Design*

GOLD
3 *Andrew Hem*
 INSTRUCTOR:
 Jim Salvati
 INSTITUTION:
 *Art Center College of
 Design*

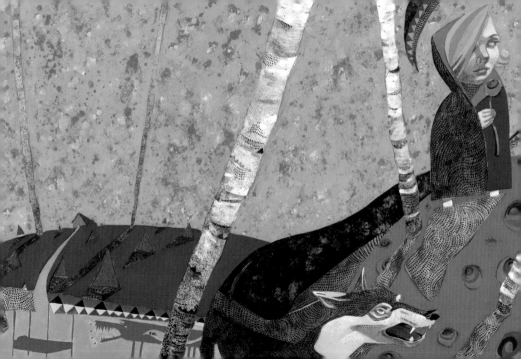

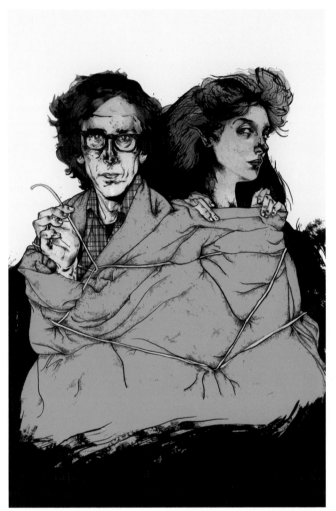

2

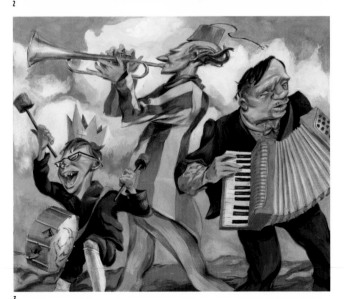

3

GOLD

1 *Stephen M. Lynch*
 INSTRUCTOR:
 Roger DeMuth
 INSTITUTION:
 Syracuse University

SILVER

2 *Justin Gabbard*
 INSTRUCTOR:
 Viktor Koen
 INSTITUTION:
 School of Visual Arts

SILVER

3 *Benji Williams*
 INSTRUCTOR:
 Allan Drummond,
 Don K. Rogers
 INSTITUTION:
 Savannah College of Art
 and Design

1

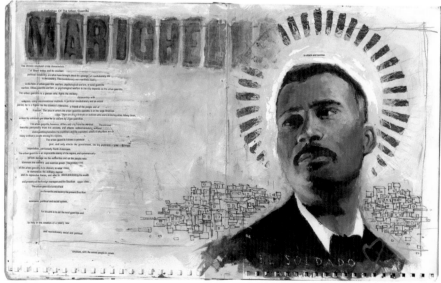

2

3

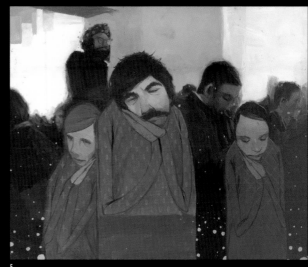

5

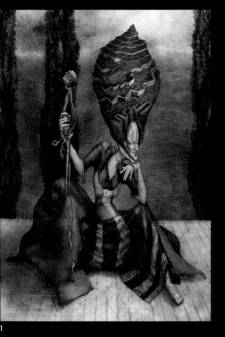

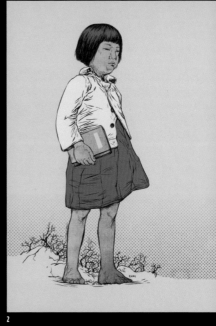

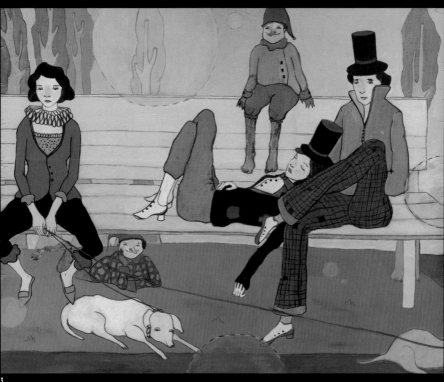

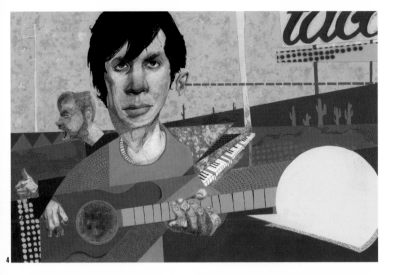

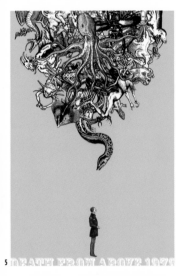

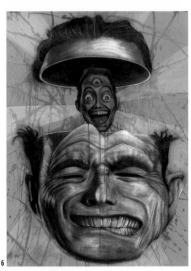

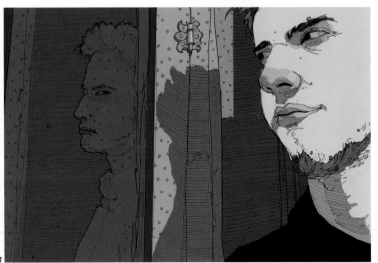

BRONZE
1 *Evette Gabriel*
INSTRUCTOR:
Allan Drummond,
Don K. Rogers
INSTITUTION:
Savannah College of Art
and Design

BRONZE
2 *Sungyoon Choi*
INSTRUCTOR:
David Sandlin
INSTITUTION:
School of Visual Arts

BRONZE
3 *Katherine Chiu*
INSTRUCTOR:
Martha Rich
INSTITUTION:
Art Center College of
Design

BRONZE
4 *Stephen M. Lynch*
INSTRUCTOR:
Roger DeMuth
INSTITUTION:
Syracuse University

SILVER
5 *Jack Elliot*
INSTRUCTOR:
Allan Drummond,
Don K. Rogers
INSTITUTION:
Savannah College of Art
and Design

BRONZE
6 *Chip Boles*
INSTRUCTOR:
Tom Garrett
INSTITUTION:
Minneapolis College of
Art and Design

BRONZE
7 *Julia Melograna*
INSTRUCTOR:
Robert Maganck
INSTITUTION:
Virginia Commonwealth
University

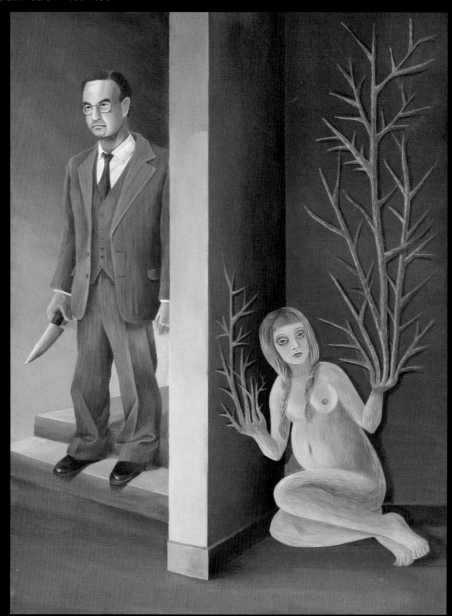

1

2

3

4

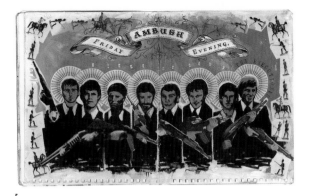

5

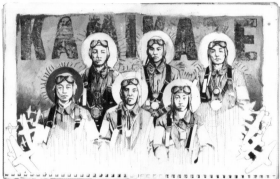

6

1 *Seung Eun Kang*
 INSTRUCTOR:
 Thomas Woodruff
 INSTITUTION:
 School of Visual Arts

2-4 *Daniel Hyun Lim*
 INSTRUCTOR:
 David Sandlin
 INSTITUTION:
 School of Visual Arts

5-6 *Jake Messing*
 INSTRUCTOR:
 Frank Olinsky
 INSTITUTION:
 *Parsons the New School
 of Design*

7 *Steven Tabbutt*
 INSTRUCTOR:
 Marshall Arisman
 INSTITUTION:
 School of Visual Arts

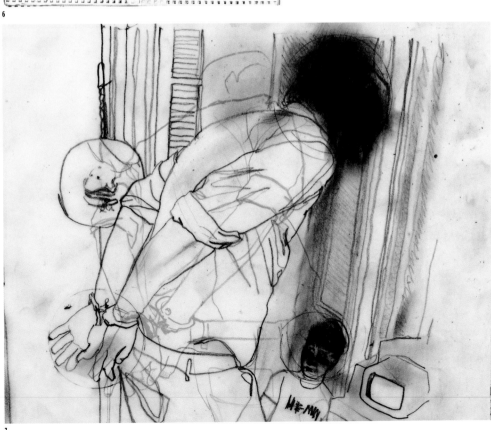

7

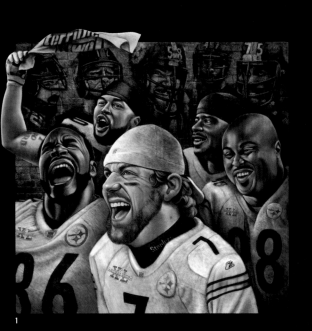

1

2

3

4

5

1-3 *Brian M. Weaver*
 INSTRUCTOR:
 David Sandlin
 INSTITUTION:
 School of Visual Arts

 4 *Chadwick Whitehead*
 INSTRUCTOR:
 David Sandlin
 INSTITUTION:
 School of Visual Arts

5-8 *Ashley Spires*
 INSTRUCTOR:
 Harvey Chan
 INSTITUTION:
 Sheridan College

 9 *Andrew Hem*
 INSTRUCTOR:
 Jim Salvati
 INSTITUTION:
 Art Center College of Design

5

6

7

8

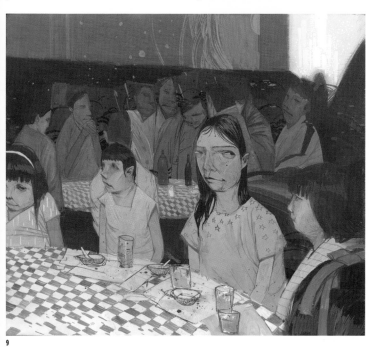

9

1

2

3

4

5

1–4 *Jason Raish*
INSTRUCTOR:
Peter Emmerich
INSTITUTION:
Fashion Institute of Technology

5 *Justin Gabbard*
INSTRUCTOR:
Viktor Koen
INSTITUTION:
School of Visual Arts

6 *Kripa Joshi*
INSTRUCTOR:
Viktor Koen
INSTITUTION:
School of Visual Arts

6

FOX KIT

2

1 *Mike Wohlberg*
 INSTRUCTOR:
 David Rankin
 INSTITUTION:
 University of the Arts

2 *Eleaun Davis*
 INSTRUCTOR:
 Allan Drummond,
 Don K. Rogers
 INSTITUTION:
 Savannah College of Art
 and Design

3 *Justin Gabbard*
 INSTRUCTOR:
 Viktor Koen
 INSTITUTION:
 School of Visual Arts

4 *Andrew Hem*
 INSTRUCTOR:
 Jim Salvati
 INSTITUTION:
 Art Center College of
 Design

3

4

NUMB

by joshua kemble

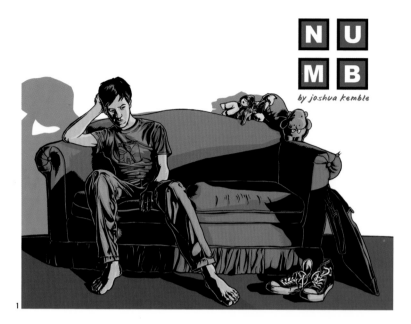

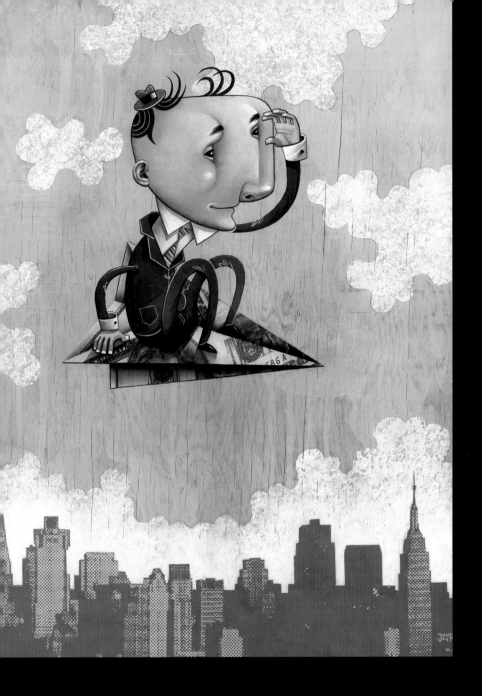

Rotating daily.
New illustration talent featured every day.
Never the same place twice.

folioplanet.com

Isabelle Arsenault

Cyrille Berger

Isabelle Cardinal

Chico

Geneviève Köte

Stephen Ledwidge

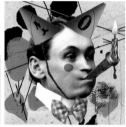
Katy Lemay

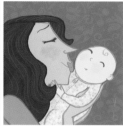
Violet Lemay

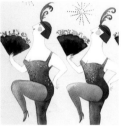
Janice Nadeau

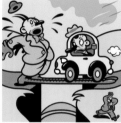
Kevin O'Keefe

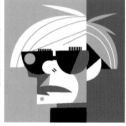
Pablo

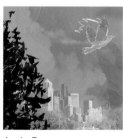
Andy Potts

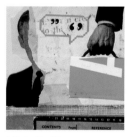
Michelle Thompson

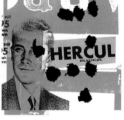
Jo Tyler

Joanne Véronneau

Matt Vincent

Costhanzo

Nathalie Dion

Gianluca Folì

Monica Hellström

Catherine Lepage

Lino

Clare Mallison

Moira Millman

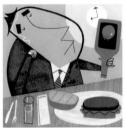
Chris Pyle

Kim Rosen

Gary Sawyer

Tyson Smith

Mario Wagner

Phil Wheeler

Terry Wong

agoodson.com

Summer 2007 THE ILLUSTRATION ACADEMY

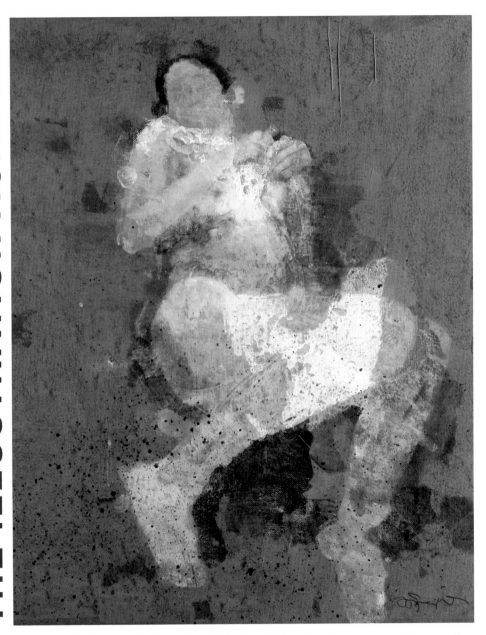

Mark English, Natalie Ascencios, John English, Sterling Hundley, Gary Kelley
Anita Kunz, Robert Meganck, C.F. Payne, George Pratt, Barron Storey, Brent Watkinson

MAY 28-JULY 13

Lecture Week:
June 18-22

941 955 8869 WWW.ILLUSTRATIONACADEMY.COM

Ringling College of Art and Design | att: The Illustration Academy | 2700 North Tamiami Trail | Sarasota | FL 34234

CHILDREN'S BOOK SHOW

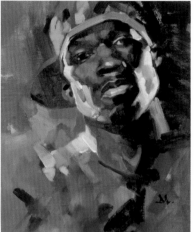

PUBLISHER'S NOTE

Every effort has been made to ensure that the
credits and contact information comply with
the information provided to us. 3x3 is not
responsible for missing information or credits.
We apologize for any omissions or spelling
errors that may have been carried through from
original submission materials.